FLORAL PAINTING

Permalba®, Turpenoid®, Jenkins Happy Medium™, Jenkins Sta-Brite Varnish™, and Floral Pink™ are Trade marked products of Martin/F. Weber Company, 2727 Southampton Road, Philadelphia, PA 19154

ISBN 0-917121-00-7

FLORAL PAINTING

by Gary Jenkins
written with
Phillip C. Myer

Credits

Publisher
Dennis Kapp

Executive Director
Edward J. Flax

Art Director
Phillip C. Myer

Editorial Assistant
Dorothy Schwartz

Color Photographer
Bill Dobos

Black and White Photographer
Kathwren Bevers

Typesetter
Lynn Dinnell

Paintings and Line Drawings
Gary Jenkins

8,10,12,14 15,13,11,9

CONTENTS

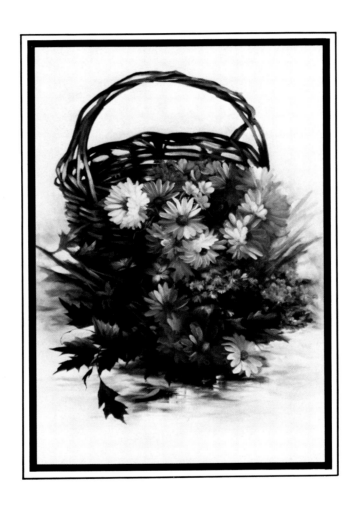

DEDICATION

I would like to dedicate this book to my mother, Mildred E. Jenkins, who believed enough in me to send me to Art School.

To my brother, Phil Jenkins, who taught me not to be afraid to be different.

And to Jack Koers who taught me how to fly with the eagles.

ACKNOWLEDGEMENTS

Thanks to Phil Myer for helping me write this book.

To Don Gerdts, from KOCE Channel 50, who believed in a cowboy who paints flowers, and put me in my first television show, "Magic of Floral Painting" on P.B.S.

I would also like to thank Mr. Dennis Kapp, President of Martin / F. Weber Company and Publisher of this book.

MEET THE AUTHOR

*Upon first meeting Gary Jenkins, one immediately recognizes that this delightful gentleman, with his laid-back country charm, has something special to offer, and indeed he does. Gary Jenkins, renowned artist and host to a public television series, **The Magic of Floral Painting**, engagingly invites everyone into the world of canvas painting.*

Gary, a New Yorker by birth and Californian by choice, began his creative endeavors when his family moved to Sarasota, Florida at the age of 12. It was there that Gary discovered an interest in art and especially floral painting as he became aware of beautiful blossoms all round him.

After studying at the Ringling School of Art in Sarasota, he graduated with honors and moved west to California. He worked as a keyline artist for a greeting card company, as well as working for a major California art supplier. It was while working for this art supplier in many capacities from picture framer to store manager, that Gary gained recognition as a true artist. After successful ventures selling his artwork and having limited edition prints made from his originals, Gary realized his work as a full-time artist. He was in great demand and has, for 20 years, been traveling nationwide teaching seminars and workshops.

Gary's talent covers a wide range of subjects beyond his gorgeous florals. He also paints animals, clowns, Indians, and realistic landscapes.

Gary has two daughters and a son — Heather, Amber, and Tim are 18, 19, and 20 respectively.

*Join Gary Jenkins with the beauty of **Floral Painting.** Together with Gary, discover the pleasures that painting can bring.*

Kimberly K. Hauser

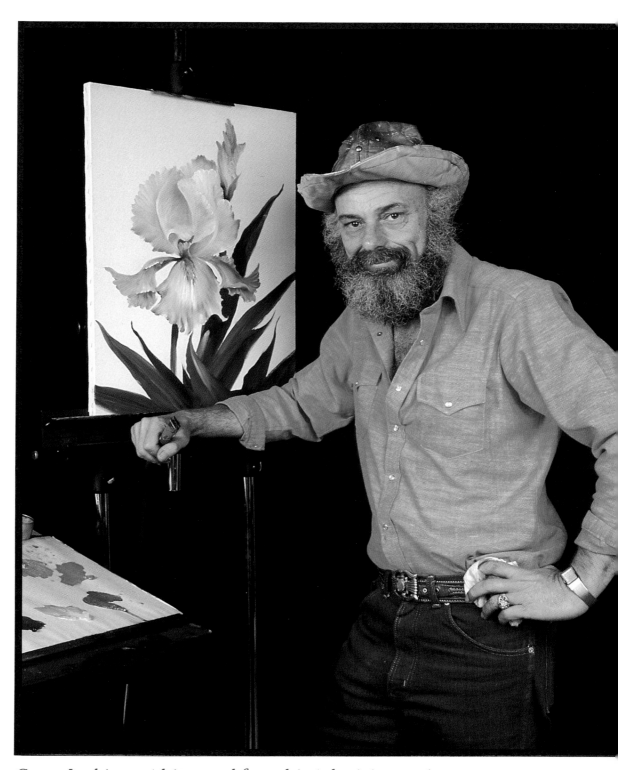

Gary Jenkins, at his easel from his television series, "The Magic of Floral Painting".

INTRODUCTION

The desire to paint is the seed that has been planted inside of you — if you have this special desire — my techniques and basic steps will take that seed and make it grow. Painting will put you on a wonderful journey. You will begin to notice and observe so much more, colors will become more important, subtle variations of the world around you will be magnified.

My flowers are very unique, sometimes I create an impressionistic flower which you will not find growing in a garden. My poppy does not exist! I have mentally crossbred a California poppy, an Icelandic poppy, and an Oriental poppy until I developed the flower I desired. Why should horticulturists have all the fun?!

My style of floral painting is very loose which enables you to go free and soar with the eagles — opening so many doors of excitement. This technique can be understood by absolutely anyone.

If you have no guts you will receive no glory — SO GO FOR IT! There is nothing to lose and so much of a colorful world to gain. Go ahead, express yourself! Let your imagination soar right up there with the eagles. Don't be afraid of the blank canvas, color can set you free.

Each year Gary Jenkins conducts Workshops on painting flowers and on many other subjects, including animals, clowns, and landscapes.

His Workshops are for everyone, from the absolute novice to the advanced professional.

For information about Gary Jenkins Workshops, please send a self-addressed stamped envelope to:

Painting Workshops
Gary Jenkins
1055 S Lyle Ave.
Crystal River
Florida 32629

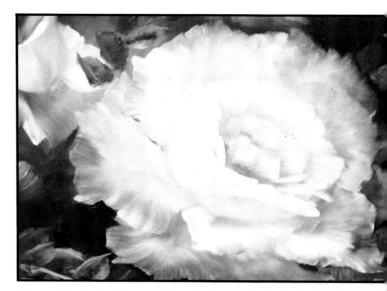

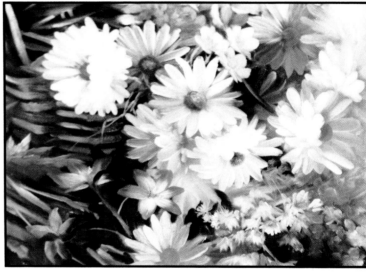

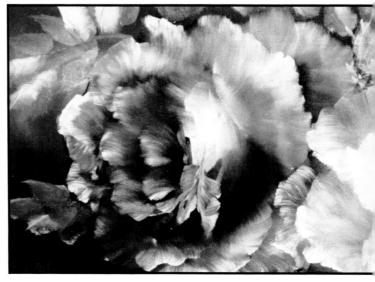

SUPPLIES

You can not paint without the proper supplies. Sure, you can use inferior paints, brushes, canvas, etc., but the end result will magnify these poor quality products. That is why I always have my beginning students start out with fine products. This will automatically cut out 45% of the initial beginners problems.

I can not begin to stress enough ... quality versus quantity ... when purchasing your artist materials. Paints and brushes are the two key supplies you will need to buy. I use Permalba Oils for my painting techniques. I have always preferred oils to acrylics due to the slower drying time. This gives you so much more time to blend and overstroke. I am not saying that floral painting can not be done in acrylics, I am only saying I prefer oils. If you already use acrylic as your medium, you should have a pretty good handle on the medium and won't have any problems converting my instructions to acrylics.

When it comes to brushes, you must work with high quality. Think about this for a moment, you can not write properly with a dull, worn down pencil, right? Well, the same is true about trying to paint with a poor brush. Your brushes should work with you—not against you.

Permalba Oil Colors

The following is a complete list of Permalba Oil Colors. It is not necessary to buy the entire line. I only want you to begin to familiarize yourself with all the color names.

Alizarin Crimson
Asphaltum
Bright Red
Brilliant Yellow Light
Burnt Alizarin™
Burnt Sienna
Burnt Umber
Cadmium Orange
Cadmium Red Deep
Cadmium Red Light
Cadmium Red Medium
Cadmium Vermillion
Cadmium Yellow Deep
Cadmium Yellow Light
Cadmium Yellow Medium
Cerulean Blue (Ultra)
Chrome Oxide Green
Cobalt Blue
Cobalt Violet Hue
Emerald Green
Flesh
Floral Pink™
Ice Blue
Indian Yellow
Indian Red
Ivory Black
Lamp Black
Leaf Green
Lemon Yellow
Manganese Blue
Mauve (True Purple)
Naples Yellow Hue
Olive Green
Paynes Gray
Permanent Green Light
Phthalo Blue
Phthalo Green
Phthalo Rose Red
Phthalo Yellow Green
Prussian Blue
Raw Sienna
Raw Umber
Rose Madder
Sap Green
Terre Verte
Turquoise
Ultramarine Blue
Vandyke Brown
Venetian Red
Vermillion
Viridian
Yellow Citron
Yellow Ochre
Gold (Metallic)
Silver (Metallic)

Original Permalba White is uniquely reliable for superior quality and permanence. It is an exclusive blend of Titanium and other pigments which were developed after extensive laboratory and practical testing. I feel the result is an outstanding, rich, creamy, white oil paint. It yields true tints of color value and exceptional brilliance; I can recommend none other for great covering power.

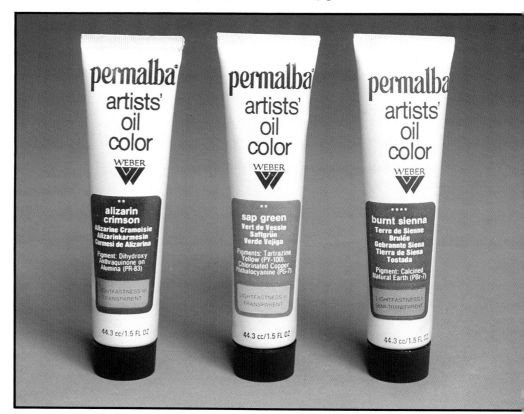

Permalba Oil Colors are vivid, intense, and wonderful paints to work with for any painter. They impart a smooth, buttery, brushing consistency.

The following are the oil colors most often used throughout this book. I have given a brief description of the colors and possible uses. Please understand that it is just a general description, the uses and the applications for oil colors are endless.

If you are a beginner, you may choose to purchase a basic palette to get started. As you continue to paint, add on to your existing color line, building as you go along. I know some day you will want to have a tube of every Permalba® oil color in your paint box, I do, and just love them all — so much beautiful color.

Alizarin Crimson — a transparent color which is a deep shading red, dark burgundy, a lovely color used in poppies, roses, and geraniums.

Bright Red — a semi-transparent oil color, which is just like its name describes — an intense, vivid, bright red hue. Great for use in pansies, geraniums, and poppies.

Burnt Umber — a semi-transparent color, which is an extremely dark value brown hue. For application in backgrounds and leaves.

Cadmium Orange — an opaque oil color, which is a medium value true orange. For application in mums, poppies, and a highlight color on dark backgrounds.

Cadmium Red Light — an opaque oil color, which is an intense orange/red hue. For application in poppies, pansies, and roses.

Cadmium Yellow Light — an opaque oil color, which is bright light value yellow hue. For application in daisies, mums, sunflowers and leaves.

Cadmium Yellow Medium — an opaque oil color, which is a medium value yellow hue. For application in daisies, sunflowers, and leaves.

Cerulean Blue — an opaque oil color, which is an intense, cool, middle value blue. For application in leaves, small flowers, and backgrounds.

Floral Pink — an opaque oil color, which is unique, bright, bubble gum, pink hue. For application as an accent in leaves or use in many flowers.

Ice Blue — an opaque oil color which is a soft, light grey blue hue. For application as an accent color in leaves, flowers, and backgrounds.

Ivory Black — an opaque oil color, which is a true and pure black. For application in deepening colors, used in leaves and backgrounds.

Leaf Green — an opaque oil color, which is a middle value yellow-green. For application in stems and leaves.

Lemon Yellow — a transparent oil color which is a very bright, light value yellow. For application in flowers and leaves.

Mauve — a transparent oil color which is a true purple hue. For application in filler flowers, roses, and fall leaves.

Permalba White — an opaque oil color which is a pure white. For application in almost every aspect of your painting.

Phthalo Yellow Green — a semi-transparent oil color, which is vibrant lime green hue. For application in leaves and backgrounds.

Raw Sienna — a semi-transparent oil color, which is a warm, soft brown hue. For application in backgrounds, leaves, and some flowers.

Raw Umber — a semi-transparent oil color, which is a dark value brown hue. For application in leaves and backgrounds.

Sap Green — a transparent oil color, which is bright, mid-tone green hue. For application in backgrounds and leaves.

Turquoise — an opaque oil color which is a bright, vibrant, blue hue. For application in leaves and backgrounds.

BRUSHES

Brushes are one of the most important tools an artist must purchase. Your brush is your key to open the world to beautiful painting. When beginning to paint, you should never skimp on poorly made, cheap brushes. You will not be able to paint and get the results you desire. An inadequate brush will not function and do the things you want it to do. You can not cut a tomatoe with a dull knife, nor can you paint with a poor quality brush.

I have been fortunate to be able to design a line of brushes that beautifully fulfill the needs of canvas painting. I designed the brushes to meet the requirements for my style of canvas painting. I hope you will give them a try.

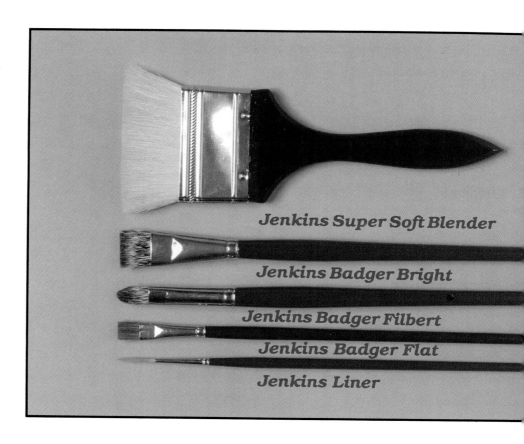

Jenkins Super Soft Blender
Jenkins Badger Bright
Jenkins Badger Filbert
Jenkins Badger Flat
Jenkins Liner

Brush Descriptions

Jenkins Badger Bright is a one inch wide, flat brush. It is excellent for use in picking out petals, a basic brush used in most everything I paint. It will be used as a basic brush for laying in color on objects and backgrounds.

Jenkins Badger Filbert is a brush which is one-half inch wide with rounded corners. It is used mainly for painting small areas such as daisies, filler flowers, and small wiggle wiggle leaves.

Jenkins Super Soft Blender is a brush which is two and one-half inches wide. It is used for blending one color into another, for application of color on large areas, and for softening hard edges. The hairs of this blending brush are extremely soft — a necessity for the techniques taught in this book. A hard bristle brush will not work — it would dig right into the canvas.

Jenkins Liner is a brush made of fine longer hairs which will pull to a fine point when properly loaded with the right consistency of thinned paint. Great for use in areas of detail, such as veins, twigs, stems, signing your name, anything in your painting which calls for a tapered narrowed line.

Jenkins Badger Flat is a flat brush which is three-eights of an inch wide, for use in painting little flowers, leaves, and smaller paintings.

MATERIALS

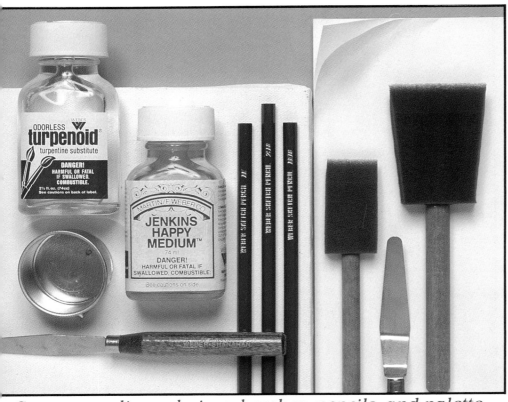

Jenkins Happy Medium is an oil painting medium for use when durability and permanence are desired. A very pale painting medium, it imparts brilliance while giving a thinner, pleasant working consistency to oils. Mix into oil colors with a palette knife or brush.

Turpenoid is a odorless, thin, and colorless turpentine substitute. Turpenoid has the same painting properties and drying time as turpentine, but is free of the strong characteristic turp odor. It is compatible with oil colors as a painting vehicle. Turpenoid is also excellent for use as a varnish thinner or solvent, paint brush cleaner, and in removing paint spots from clothing.

Canvas, mediums, knives, brushes, pencils, and palette

Canvas is another important tool of the artist. I prefer a canvas with a smooth portrait finish. My techniques require a lot of stroking and blending, so a rough texture canvas would eat up your brushes quickly.

Jenkins Medium Cup is a perfect container to keep your Jenkins Happy Medium in. It comes with a handy clip to attach to your palette.

Palette Knife is helpful in mixing your oil colors to create different hues and also for mixing mediums into the oil colors. Knives are available in trowel, straight, and assorted shapes and sizes.

Drawing pencils are used in sketching and transferring your designs onto the canvas.

Sponge brush is used for applying any acrylic background colors to the canvas before oil painting is started. These brushes are available in one inch and two inch sizes.

Palette Paper — a disposable palette paper pad is very convenient to use. The surface for an oil palette should not be too slick, not too absorbent. Pads are available in all sizes and shapes. I prefer a nice size palette for plenty of room to mix the colors (12 x 16 range is ideal).

Jenkins Sta-Brite Varnish — this is a spray varnish which is a colorless, light-bodied varnish for temporary protection of oil paintings. Sta-Brite brings out color intensity and highlights the areas which dry flat and dull. Drys fast with a gloss finish which is non-yellowing.

Damar Varnish — it is a natural picture varnish which gives a high gloss, strong protection, and increased brilliance to finished oil paintings. Apply Damar Varnish with a soft hair varnish brush.

Transferring Designs

For all the paintings in this book, a pen and ink line drawing has been provided. This may be used to trace and transfer directly or used as a sketching reference when drawing a design onto canvas.

For direct transferring, trace the basic outline of the design onto tracing paper. Position tracing on canvas and tape down, slide a piece of graphite carbon paper inbetween and lightly go over the basic lines.

The designs in this book are for a medium size canvas. I prefer to work a little larger, so graph drawings are included for the purpose of enlarging these designs.

Mixing Medium Into Oil Colors

The Jenkins Happy Medium was designed to mix with your oil color for changing the working consistency of the paints. The obvious will occur — the more medium you add to the colors, the more they become fluid. As a general rule, I always mix my oil paints with the Happy Medium. There are three consistencies I work with in my paints, a mayonaise consistency, a flowing consistency, and an ink-like consistency. I generally dip my brushes into the medium and then into the oil colors for a brush mixing technique. You can also use a palette knife to do your mixing, I prefer to use my brush.

The mayonaise consistency has a small amount of medium, the flowing consistency has a medium amount, and the ink-like consistency has a lot of medium added to the oil color.

Dry (No Medium)

Several times in this book, I mention using your oil color dry — by this I mean no addition of Happy Medium is to be used. I do not mean to use dried oil color.

Acrylic Background

I have painted some of the designs in this book in a graphic look. In these paints, there is no blended color background. I worked on a one tone color background, using an off-white acrylic base. I choose acrylics for this technique because of their quick drying characteristic.

To paint in an acrylic background, we will use a sponge brush to apply a smooth even coat. Let the first coat dry thoroughly before applying a second. Two coats should produce an opaque coverage. Let the acrylic on the canvas dry thoroughly before continuing.

Loading Your Brush

A properly loaded brush is essential for accurate painting. You will save yourself a lot of time if the brush is loaded properly the first time. To start, dip the brush into your Jenkins Happy Medium, then stroke the brush through the pile of paint — applying paint to both sides of the brush. A properly loaded brush will have every hair saturated with color and medium. After you have initially stroked through the paint, move the brush to another spot on the palette and work the color into the brush. You should be constantly flipping the brush so both sides of the brush are covered.

Wet-In-Wet Technique

Most of what I do when painting is a wet-in-wet technique. By this I mean working with one color on top of another while both oil colors are wet. Many unique effects are created when working with the wet-in-wet technique. Truly, these techniques can not be planned, they just occur. This is the beauty of painting — so many happy accidents will happen for you. Please do not be uptight while working with this technique, relax and have fun. Soar with the eagles!

Reflections

Reflections are a super addition to finish off a beautiful painting. Hints of color from the main subject are placed in the foreground area. This will create a harmonious feeling to the painting.

Color is applied with your Jenkins Badger Bright in quick, short, downward strokes. Then the edge of the brush is zigzagged through, breaking up the stroke direction of the reflection colors.

Reflections should be placed on just below the subject in the foreground area. They should not extend too great of a distance.

BASICS

Large Leaf Stroke: *Photo Series 1*

The basic stroke of the larger leaf is quite easy to learn. The larger leaves in my designs are painted with your Jenkins Badger Bright. A dark base is applied first, stroking from the ragged edges to the center vein area of the leaf.

Touch the brush to the surface, apply pressure, drag, pull, and lift the brush up as you come towards the center vein. Stroke in the entire left side of the leaf first, then stroke in the right side of the leaf. Start at the base of the leaf and continue to work up the side of the leaf, 'til you reach the tip. Angle the brush, so the corner of the brush creates a ragged edge. Remember to taper the shape as you work towards the tip of the leaf.

The leaf is overstroked in a lighter color in the same procedure. Use a light touch if you wish to achieve a lot of light color on the leaf, heavy if you wish to have more of the dark base showing through. Additional accents and highlights may also be applied to the leaf. Vein the leaf using the chisel edge of your Jenkins Badger Bright. Stroke the vein in in a curving linear stroke.

Wiggle Wiggle Leaf Stroke: *Photo Series 2*

This leaf is quite unique and a lot of fun to paint. Your Jenkins Badger Bright is used to paint this leaf. Load the brush with the desired color, touch the brush to the surface, and begin to make an up and down movement, wiggling the brush. This will form the basic oval shape of the leaf. Once you have formed the basic shape, lift the brush up to the chisel edge and stroke out to form a small tip to the leaf.

This style leaf is very seldom painted singly, it is usually on a thin stem with several other leaves. Stroke on a thin stem with the chisel edge of the brush, then stroke on the wiggle wiggle leaves off of the stem.

Small Flower Stroke: *Photo Series 3*

The small flower is painted using your Jenkins Badger Filbert. Usually I paint this flower in five petals. Shown in the photo series is a cupped flower (one which is foreshortened). The two front petals are directed towards us, so we are only seeing a portion of these petals.

The stroke of the petal is accomplished by touching the brush to the surface, applying pressure 'til the desired width of the petal is achieved, pull, drag, and lift up on the brush. I generally stroke on three back petals and two towards the front.

When painting a foreshortened flower, the front petals are stroked on as slice like strokes. You will mainly use the chisel edge of the brush for that purpose.

Criss Cross Stroke: *Photo Series 4*

This stroke is mainly used in color application of large areas. I apply a great deal of criss cross strokes in my backgrounds. The paint consistency is similar to mayonaise when working with the criss cross method.

Use your Jenkins Badger Bright to stroke color on the canvas. When you are painting the criss cross stroke, think of forming X's. Build up on the layers to reach an opaque area on the canvas. You can easily interblend color on the canvas by using the criss cross stroke when placing on another color.

Push Pull Stroke: *Photo Series 5*

The push pull stroke is one of the fundamental strokes you should learn. It will help you develop proper brush control. If you will practice this stroke, it will aid in giving you confidence with your brush strokes and brush handling.

The push pull stroke is accomplished using the side of your Jenkins Badger Filbert. To start, load your brush fully with paint which has a flowing consistency. Touch the brush to the surface using the side, apply pressure, drag, pull, and lift up quickly — bringing the brush and stroke to a point. This is a stroke which should be done quickly without hesitation. Practice this stroke until you are confident with it, the rewards will come to you.

Stroking On The Daisy: *Photo Series 6*

The development of the daisy consists of two different strokes. First, you will stroke the petals on with the push pull stroke. Start from the tip of each petal and stroke in towards the center of the daisy.

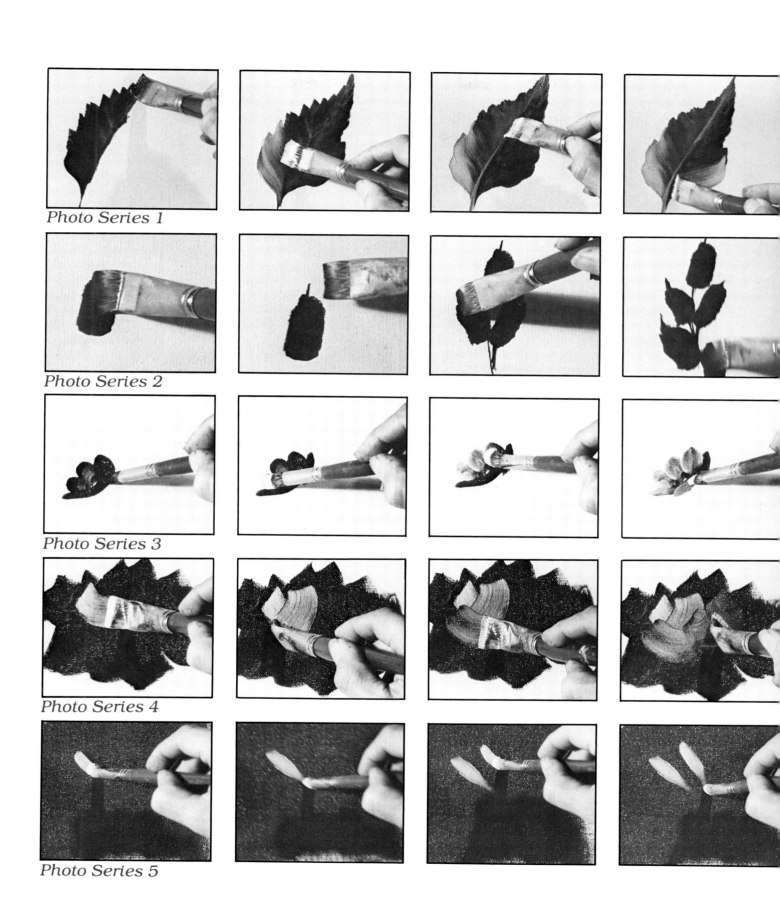

Photo Series 1

Photo Series 2

Photo Series 3

Photo Series 4

Photo Series 5

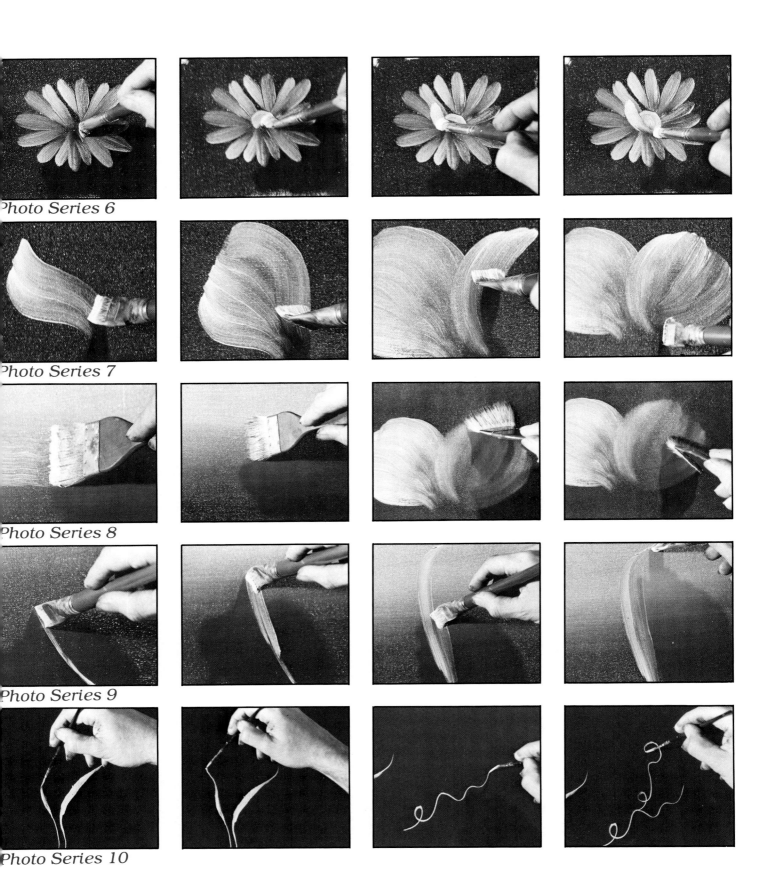

Photo Series 6

Photo Series 7

Photo Series 8

Photo Series 9

Photo Series 10

Place in all petals of the daisy — then the center is painted in with a circle stroke.

The circle stroke is completed by using your Jenkins Badger Filbert. Touch the brush to the surface, apply pressure, curve the brush — arching it to the right. Bring the brush to a complete circle.

An additional flipped petal may be placed in the daisy by stroking in a curving, push pull stroke — slicing it around the center.

Large Petal Stroke: *Photo Series 7*

The large petal stroke is used on the flowers which have wide, flowing petals, such as the poppy. The Jenkins Badger Bright is used in this technique. Load your brush with plenty of paint, stroking through color and medium to properly fill the hairs.

To begin the petal stroke, touch the chisel edge of your Jenkins Badger Bright to the very edge of the flower, push down to apply pressure, pull, drag, and stroke towards the flowers center area. You will not taper the stroke like the push pull stroke, this stroke will just stop at the center area.

To complete an entire petal, follow the same technique-placing one stroke overlapping another. Be sure you curve the outer strokes of the petal and to give the petals edge a ragged look (never a straight edge).

To place one petal over another, simply over-stroke the first brush stroke partially on top.

Blending and Softening Strokes:
Photo Series 8

All of my blending and softening techniques are completed with your Jenkins Super Soft Blender. This brush is crucial to the results of your paintings. The hairs of this brush are extremely soft, enabling you to create subtle blending techniques.

A light touch is also essential during this process. In this photo series, you can see the blending of colors in a background and the softening in a flower petal. Sweep your brush over the surface lightly — think of an airplane coming in for a landing. If too much pressure is applied, you will be taking off the paint, instead of blending and softening. You can easily create mud with the colors on the canvas if too much time is spent. Get in there and get out! Remember if you mess up — that's ok, if you are not making mistakes, you are not learning anything.

Blade Leaf Stroke: *Photo Series 9*

The blade leaf stroke is mainly completed with the chisel edge of your Jenkins Badger Bright. This stroke is painted starting at the bottom stem edge and working to the tip of the leaf.

Touch the chisel edge of the Jenkins Badger Bright to the surface and begin to stroke upward. After a thin stem line is complete, slightly twist the brush counter-clockwise to give more width to the blade — continue up forming the mid-section. Once you begin to reach the tip area, gradually turn the brush back to the chisel edge forming a tapered edge. The blade may be widened in the mid-section by stroking along side your previous stroke.

Linework Stroke: *Photo Series 10*

Of course, it is obvious that you will use your Jenkins Liner brush for this technique. The major key to this work is proper paint consistency and a brush with a fine point.

Mix plenty of your Jenkins Happy Medium into the desired oil color. The paint should have the consistency of ink, for it must flow off of the brush's tip as ink flows from a pen point. Load the Jenkins Liner with plenty of paint — saturate every hair of the brush. Finally, twist and twirl the brush bringing the hairs back to a point.

It is that very point where the linework should come from. To do linework, you should hold the brush as loosely as possible. If the brush is held too tightly, your linework will be stiff and rigid. Loosen up, don't be uptight, relax it will come with practice. The linework is used to do thin stems, trendels, and signing your name.

FLORALS

The magic of florals is a real turn-on! The color that overflows (like a waterfall) is absolutely outstanding. You can really make things happen when painting—and florals are an excellent starting point. Please don't be timid about using a lot of color, flowers are abundant with vibrant hues.

Remember a few key phrases that I tell you, such as your darks go in first, and the highlights (goodies) go in last, then you will have no problem painting beautifully. If you are not making mistakes (messing up) as you go along, you are not learning.

Florals, for a beginner, are an ideal subject to start painting. If you are that novice, relax and have fun. My style of painting is loose and carefree. The flowers we are about to start painting are large, enabling you to have less problems. I do not choose to work small and very tight, my painting flows and dances upon the canvas. Be free, soar with the eagles, but most of all—have fun!

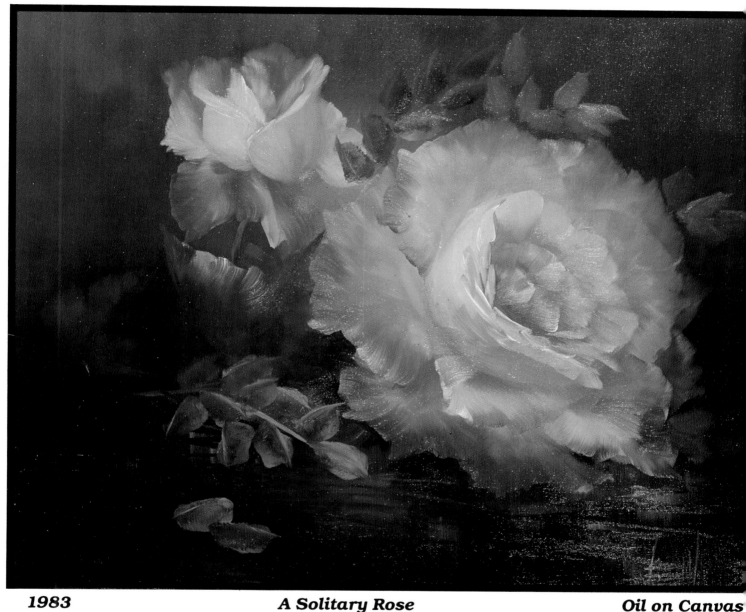

1983　　　　　　　　　*A Solitary Rose*　　　　　　　　　*Oil on Canvas*

COUNTRY-STYLE DAISIES

Daisies are informal, old-fashioned, country flowers. One of the easier flowers to paint, you will enjoy how quickly they blossom before your eyes. Just with one simple stroke, the petal of the daisy is formed. Please do not limit yourself to only white daisies! How boring, daisies come in all sorts of colors. If they do not grow in a particular color in real life, you can still paint them in the color of your choice. Remember, you are the artist, you can create your own nature.

I feel the loose and rustic woven basket is an ideal partner for the daisies. The country daisies are joined by nostalgic filler flowers. These smaller additional flowers aid in bringing our composition together. I have also included a grouping of rust leaves in the foreground to give an exciting contrast to the painting. This project is going to blow your mind.

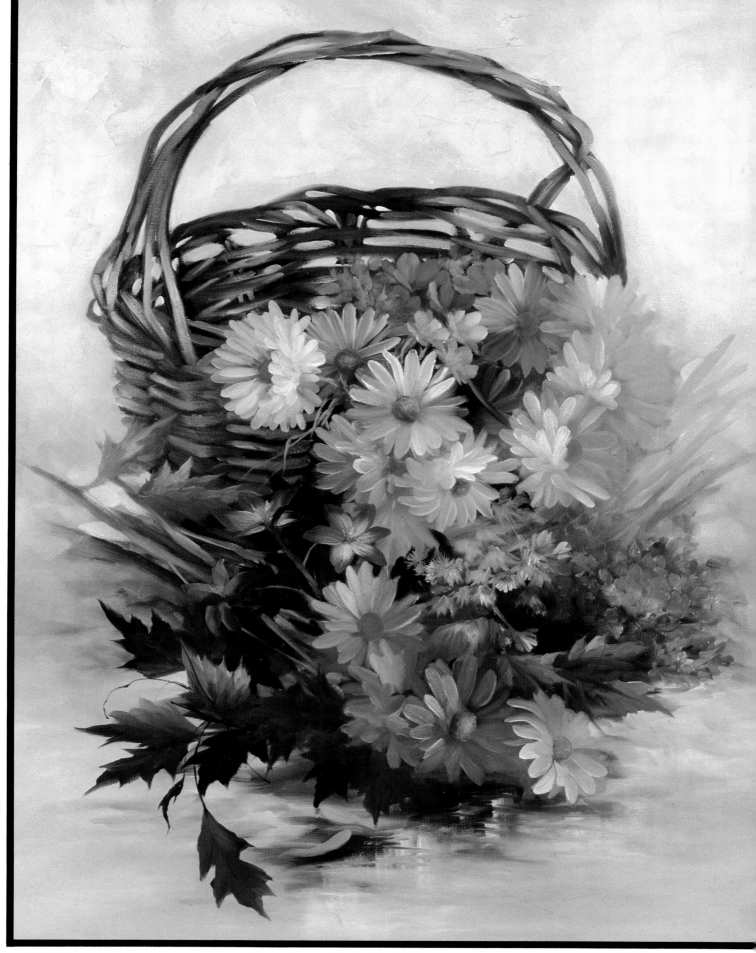

DAISIES

Colors

Permalba White	Mauve
Yellow Ochre	Cerulean Blue
Lemon Yellow	Cadmium Yellow Medium
Leaf Green	Raw Umber
Alizarin Crimson	Burnt Sienna
Phthalo Yellow Green	Ice Blue
Bright Red	Sap Green

Brushes

Jenkins Liner
Jenkins Badger Flat
Jenkins Badger Filbert
Jenkins Badger Bright
Jenkins Super Soft Blender

Canvas Preparation: *Transfer Design*

We will begin by lightly sketching or transferring the design to the canvas. Be careful not to bear a lot of pressure when transferring design, or you can make an indentation into the canvas.

Color Placement: *Background*

Using the Jenkins Badger Bright, apply a mixture of Yellow Ochre plus Permalba White in a criss-cross stroke manner around the top half of the canvas. Carefully brush the paint around the basket and basket handle. You should apply some background color inbetween the basket strands in the back section.

Now place a mixture of Permalba White plus a touch of Burnt Umber on either side of the basket in the mid-section of the background. Next brush mix Burnt Umber plus Alizarin Crimson and stroke this on in the criss-cross method, applying color around the lower flowers and leaves. Strengthen the shadow area around the lower flowers and leaves with Alizarin Crimson deepened in Burnt Umber.

The remaining lower section of the canvas background is coated in the criss-cross method with a mixture of Permalba White plus touches of Yellow Ochre and Cadmium Yellow Medium. Place this color on carefully going around the Alizarin area — do not drag the Alizarin around into other areas. Please note all colors that were placed on in the background area had the addition of Jenkins Happy Medium, to enhance the movement of paint.

In the criss-cross method, lightly blend the color sections together in the background. Do not overblend, you do not want to achieve a one tone background. The objective is to break the heavy division line between one color section and another. Leave it very brush strokey, do not softly blend this area.

Using your Jenkins Badger Filbert, place in a little Burnt Umber around the daisies, in the middle section and bottom section of the basket. This will give depth, so the daisies will not be flat.

Add a mixture of Cerulean Blue, Bright Red, and Permalba White to the mid-section of the background. Place this on either side of the basket, stroking it on in a criss-cross method. This effect should produce a slight hint or touches of this coloration in the background.

Color Placement: *Basket*

Before you begin to paint the basket, check to see if you have placed background color inbetween the weaves of the basket.

Brush mix Raw Umber plus a touch of Burnt Sienna, using your Jenkins Badger Filbert begin to carefully lay in the weaves of the basket. Thin your colors with Jenkins Happy Medium at all times, the paint needs to flow properly when painting the basket. Next, lay in a very thin wash of Burnt Sienna on the front section of the basket, let your tracing show through — this will be helpful in finding the individual weaves.

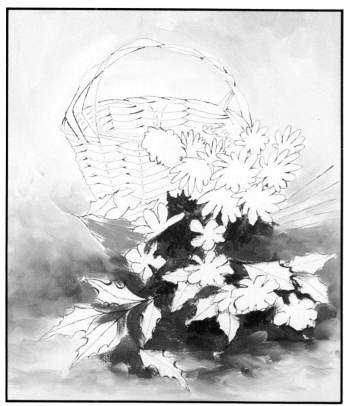

1st Stage

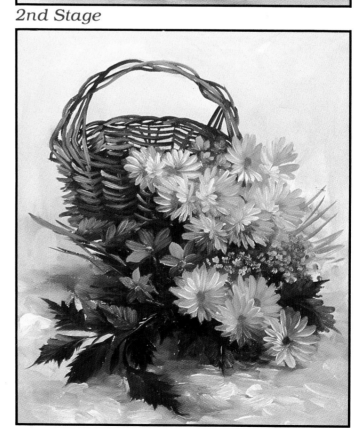

2nd Stage

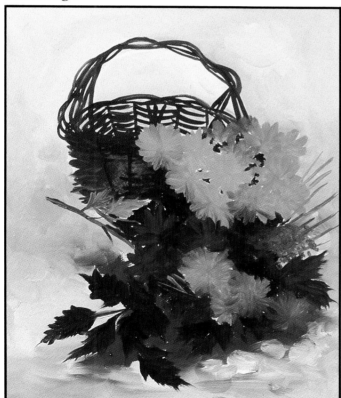

3rd Stage

4th Stage

27

Stage 1
Basic color placement of background is stroked in around basket, leaves, and flowers.

Stage 2
Color placement of the basket and off-white daisies are stroked in.

Stage 3
Entire color placement of flowers and leaves.

Stage 4
Overstroking and highlights are placed in for final blending and softening.

Using the Jenkins Liner and thinner Burnt Umber, sketch on the vertical lines of the basket. This will aid in stroking on the horizontal twigs. We are going to pull highlights out of this dark area to form individual weaves a little later.

Color Placement: *Daisies*

Using the Jenkins Badger Filbert and Ice Blue, begin to block in the petals of the off white daisies. Stroke on the color from the tip of the flower towards the center using the side of the brush. If you happen to pick up surrounding color into the daisy — *that's ok — in fact, it is great!*

Apply a base tone of Yellow Ochre in the same manner to the yellow daisies. You will probably pull some of the Alizarin in, which will give them a red tinge. Don't be worried — *that is ok!*

Color Placement: *Filler Flowers*

Cerulean Blue is used to base in the wild flowers at the top and the lilacs towards the bottom. Apply this color using the Jenkins Badger Filbert.

Color Placement: *Leaves*

The rust leaves which are towards the front of the design are based in a mixture of Alizarin Crimson plus Burnt Umber. When applying colors to the leaves, start from the center of the leaf and stroke towards the tip.

The green leaves and stems are painted in a mixture of Phthalo Yellow Green and Sap Green. Add a little Jenkins Happy Medium so paint does flow properly.

Basket:

Using Ice Blue (a grey-blue), begin to pull out individual weaves with the side of the Jenkins Badger Filbert. You should try and think of how a basket is woven together when stroking on this highlight color.

Begin to stroke on the horizontal twig weaves. You should vary their distance and size. Remember this is a rustic basket, leave it loose and free. The left side of the basket is kept ragged, do not create a straight edge.

Final highlights of Permalba White are placed on some of the top twig weaves. Light accents of Yellow Ochre are added here and there using the Jenkins Badger Filbert.

Daisies:

Establish the daisy centers in a mixture of Bright Red and Cadmium Orange using the Jenkins Badger Filbert. Dab this color in the centers.

Now, using Permalba White thinned with Jenkins Happy Medium begin to stroke on the individual daisy petals of the off white flowers. You will be stroking over the Ice Blue base. Use the side of the Jenkins Badger Filbert to do this. Highlight a few of the petals with a coat of pure, dry, (no medium) Permalba White.

The yellow daisies are overstroked in a mixture of Lemon Yellow plus Permalba White, leave some back petals with the base Yellow Ochre showing through. Final highlights of dry Permalba White are placed randomly.

Filler Flowers:

The violet color flowers are painted with push-pull strokes. The base of these flowers is Alizarin Crimson with Permalba White overstrokes. The centers of these flowers are painted in Lemon Yellow.

The tiny wild daisies are painted in Permalba White following the same technique as the larger ones. It is ok if some of the flowers fade into the background.

The lilacs are stroked on with a mixture of Permalba White and Cerulean Blue. These small flowers have five petals. Stroke these petals on using the Jenkins Badger Flat.

Blue flowers towards the top of the design are overstroked in a mixture of Cerulean Blue plus Permalba White. Use the Jenkins Badger Filbert for this flower petal.

Leaves:

The rust leaves are overstroked in a mixture of Alizarin Crimson plus Permalba White. Tip a

few leaves in Bright Red and Cadmium Red Light. Always stroke from the center of the leaf towards the tip. This method will create the individual veins. A few leaves were tipped in Floral Pink.

Highlight the green leaves and stems Lemon Yellow using the Jenkins Badger Bright.

Finishing:

Sign your name using the Jenkins Liner brush and thinned paint. Let your painting dry thoroughly, before applying several coats of Jenkins Sta-Brite spray varnish to bring out the color intensity.

The following graph has been provided to enable you to enlarge the design. Increase the line graph double or more in size and sketch the design using this drawing as a guide. Do not feel you must copy it exactly—for you are the artist—create your own painting in the process.

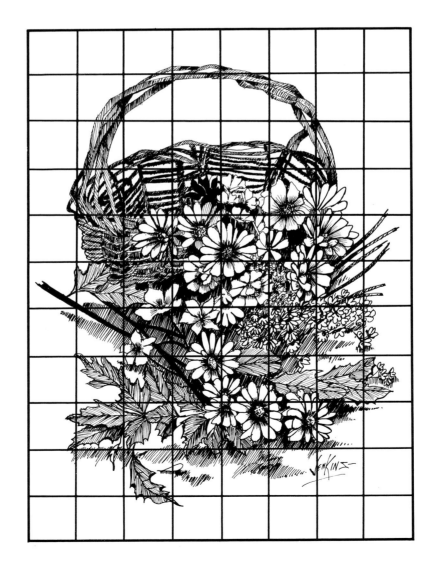

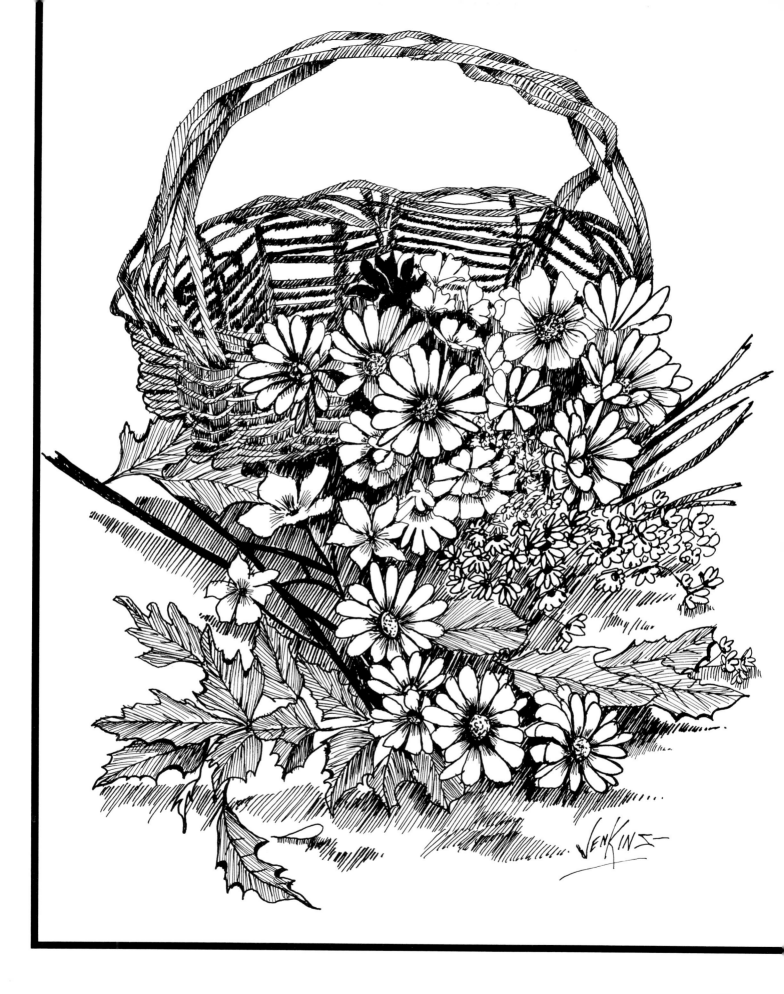

31

A BURST OF MUMS

Chrysanthemums are such beautiful and versatile flowers. They can be treated many different ways, easily adapting to the setting they are in. For example, mums are simply stunning in an elegant setting or down right at home in a country setting. I feel that they are one of those in the middle of the road flowers. It is truly up to you where you take them. It is usually in what the mums are combined with that sets these flowers in a particular style. I choose to compliment the mums with a few daisies for a country, homey style look. You could easily change the daisies to baby's breath for an elegant look.

The mums are basically a stroke flower, developed by stroking on petals in a series of layers to create a tremendous amount of dimension. You should not fuss at each individual petal or you will over blend. Try to look at the flower as a whole, rather than separate pieces.

Let your imagination soar with the eagles, do not be timid about experimenting. For this is the only way for you to truly learn.

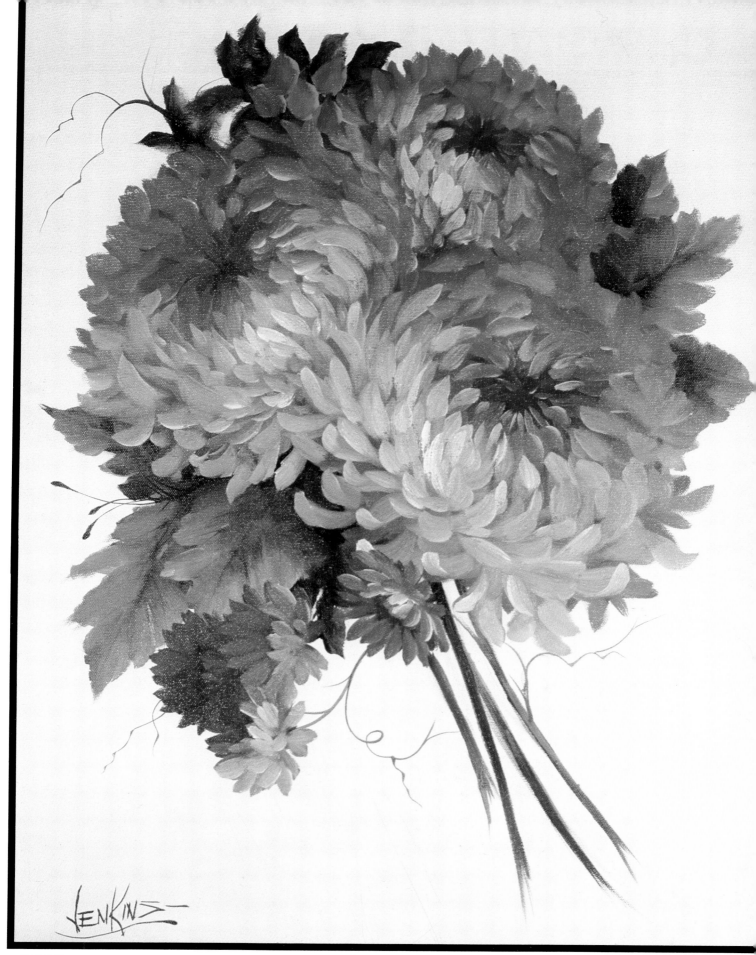

1983 *A Burst of Mums* *Oil on Canvas*

CHRYSANTHEMUMS

Colors

Permalba White

Alizarin Crimson

Cadmium Orange

Sap Green

Burnt Sienna

Floral Pink

Leaf Green

Lemon Yellow

Brushes

Jenkins Liner

Jenkins Badger Filbert

Jenkins Super Soft Blender

Canvas Preparation: *Basecoat Color*

We will begin by placing on a light coat of an off-white acrylic basecoat. Since this design is done in my modern graphic look, no blended oil painted background will be done. Using a sponge brush, apply several light and smooth coats to the canvas. Let each coat thoroughly dry before applying another coat. Let final coat dry. Acrylic paint dries rapidly, so you should be ready to paint the design in an hour.

Lightly sketch or transfer the design to the canvas. It is not necessary to sketch on all the individual petals of the mums, a basic circle and simple indication of extended petals are sufficient.

Color Placement: *Leaves*

Apply a mixture of Sap Green and Burnt Sienna at the base of all the leaves and around the mums. Place the color on in a ragged manner, do not create a straight edge around the mum's petals.

The small leaves at the top of the design are the wiggle wiggle style leaf. Using the Sap Green and Burnt Sienna mixture and your Jenkins Badger Filbert, stroke these leaves on.

The larger leaves are stroked on using the same color mixture. Start from the ragged edges and stroke towards the center of the leaf. We are just putting in our darks on the leaves now, we will put in the goodies (highlights) later.

Color Placement: *Chrysanthemums*

Apply a mixture of Cadmium Orange and a touch of Burnt Sienna, thinned with Jenkins Happy Medium, to the entire mum shapes. Keep outer edges ragged all the way around each mum. When applying this color, you may pick up a little green from the leaves into the mums — *that's ok!*

Next, place a little Alizarin Crimson in the inside center of each mum. Soften the edge of this circular color into the Cadmium Orange base tone. On the two front mums, place Alizarin Crimson on the right hand side, on the mum in the back, place Alizarin in a "V" shape where it touches the other two mums. Softly blend this color into the base tone.

Chrysanthemums:

We are now going to start the individual petals of the mum. The mum petals must be developed gradually, starting with dark value petals, then to middle value petals, and then onto the light value petals. The petals are painted with the push down — pull stroke using the side of the Jenkins Badger Filbert.

The first series of petals will be stroked on using a mixture of Cadmium Yellow Medium plus a touch of Permalba White. Start at the center of the flower and work out, you will create a row of petals around the very center. Think of a crowd all hovering around a spectical for initial petal direction. Study painting to follow stroke direction of petals.

The petals towards the back are closer together and less distinct. They tend to melt away, blending into the midtone base color. Most students will make the mistake of not enough petals, we want to create many layers — layer upon layer. Take the time and go to the nursery and study the mums, really notice how many petals do exist. Also, remember not to have all your flowers facing the same direction.

The next series of petals to be placed on will be middle value. They are stroked on in the same manner using a mixture of Permalba White and Cadmium Yellow Medium. Randomly place petals over each mum developing the layer look. Let some petals curve out beyond the edge, although mums are tight flowers, we, as artists, do not have to paint them that way! Remember, you are the one creating, do not always stick to the rules of nature — *have fun — create!*

The last series of petals placed on the mums will be our highlights (light value petals). These will be stroked on using Permalba White. Use your highlights sparingly — too many highlights and our mums will get very flat looking, place very few highlights towards the back of the mum. The brightest highlights you see on my mums are pure Permalba White. No medium was added to final highlight color — this will make it sit on top.

You may choose to stroke on a few turned strokes on the very edge of a petal for a flipped petal end.

Stand back and view your mums, you should be able to pick out three distinct values.

Leaves:
Highlights are placed on the leaves. We will work on top of the dark base which has already been stroked on the leaves. A mixture of Lemon Yellow and Leaf Green is used as the highlight color. Using your Jenkins Badger Filbert, stroke from the top of the large leaves towards the center vein area. Be sure that you leave dark areas near the flowers. Also, stroke on some wiggle wiggle style leaves of this light green at the top of the design. Remember your paint should stroke on properly by the addition of

Jenkins Happy Medium. Final highlights of pure Lemon Yellow should be added sparingly. Tip edges of a few leaves with Floral Pink accents.

Stems:
Stroke stems on using the chisel edge of the Jenkins Badger Bright and a mixture of Sap Green and Burnt Sienna. Highlight with Lemon Yellow plus Leaf Green.

Small Daisies:
A few small daisies were placed in towards the bottom of the design to add a little more color to the composition.

Block the daisy shapes in Alizarin Crimson which has been thinned with Jenkins Happy Medium. Using your Jenkins Badger Filbert, overstroke individual petals in Floral Pink.

Another layer of petals are then stroked on, in a mixture of Floral Pink plus Permalba White. Always use the side of the Jenkins Badger Filbert to create the daisy petal. Final highlights are stroked on with dry (no medium) Permalba White.

Vines:
Using your Jenkins Liner Brush and Leaf Green which has been thinned with Jenkins Happy Medium to a flowing consistency, stroke on the individual vines. The most important key to this technique is flowing, thin consistency paint. In order to paint light, thin vines you must have the proper consistency. Don't paint too many vines - or the painting will get cluttered.

Finishing:
Sign your name using the Jenkins Liner Brush and thinned paint. Let your painting dry thoroughly, before applying several coats of Jenkins Sta-Brite Spray Varnish to bring out the color intensity.

The following graph has been provided to enable you to enlarge the design. Increase the line graph double or more in size and sketch the design using this drawing as a guide. Do not feel you must copy it exactly—for you are the artist—create your own painting in the process.

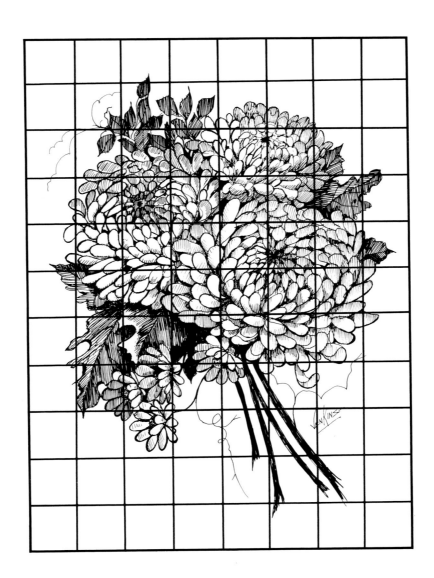

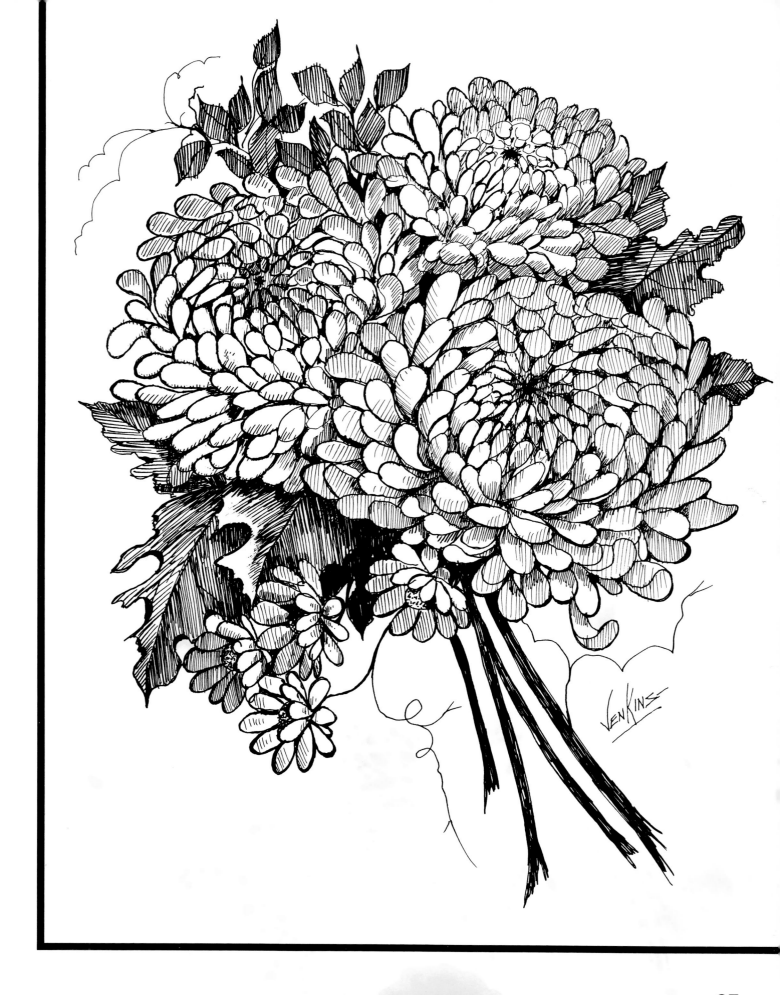

37

SHEER ROSES

I feel roses are one of the most elegant flowers of all — the ultimate horicultural species. They grow in endless variations and color schemes. The cross-breeding that has recently occurred has brought us some of the most unique roses to date. They are truly a romantic flower. Beautiful, delicate, and sheer — for years roses have been a symbol of love — when given by a man to a woman. I'm sure painting these beauties will bring to mind your loved one, filling your heart with happiness.

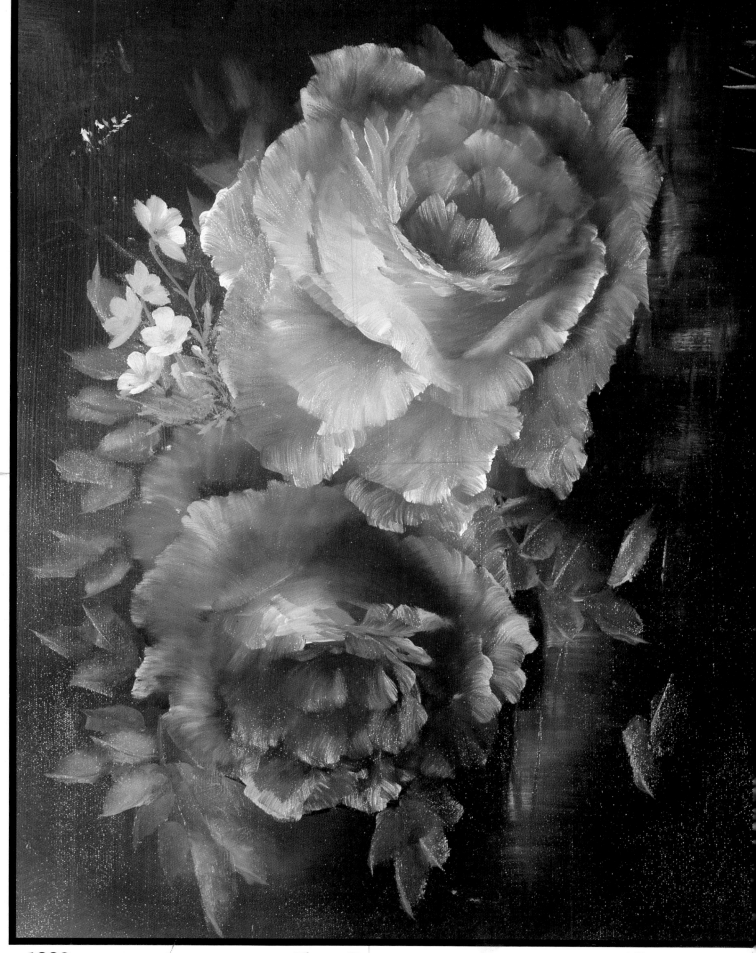

1983 **Sheer Roses** **Oil on Canvas**

ROSES

Colors

Sap Green	Cadmium Orange
Leaf Green	Ivory Black
Burnt Umber	Cerulean Blue
Burnt Sienna	Phthalo Yellow Green
Alizarin Crimson	Permalba White
Floral Pink	Bright Red

Brushes

Jenkins Liner
Jenkins Badger Filbert
Jenkins Badger Bright
Jenkins Super Soft Blender

Canvas Preparation:

The roses were painted with a blended color background. In my method of painting roses, I usually do not sketch or transfer a design. Though, if you wish to sketch or transfer general rose placement that is ok.

Color Placement: *Roses*

Pick up your Jenkins Badger Bright and load it with Alizarin Crimson which has been slightly thinned with Jenkins Happy Medium. Sketch in two circle shapes on the canvas, refer to the color plate for placement.

The back circle shape is filled in with a thin coat of Alizarin Crimson, stroke on from the center out — leaving ragged edges all the way around. The other circle shape (bottom rose) is filled with Cadmium Orange in the same manner.

Color Placement: *Leaves*

Using the Jenkins Badger Bright, brush mix Sap Green and Burnt Sienna with Jenkins Happy Medium. Apply this color around the roses for initial leaf placement. Stroke color on in the criss-cross method. Notice how the green color begins to help the flowers pop.

Color Placement: *Background*

Brush mix Burnt Sienna and Burnt Umber to a warm brown. Using the Jenkins Badger Bright, place the warm brown mix on the top two thirds of the canvas. You should always be adding a touch of Jenkins Happy Medium to your colors to make them stroke on smoothly.

Bring color placement right to leaves and roses, overlapping is ok. On the bottom section of the canvas, place a mixture of Ivory Black and Burnt Sienna in the same manner. You may need to soften the background colors now, do so by blending with the Jenkins Super Soft Blender.

Highlight the top of the canvas with Cadmium Orange in a wet-in-wet technique — mixing color on the canvas rather than on the palette. Use the Jenkins Badger Bright for this technique - soften with Jenkins Super Soft Blender.

Roses:

Using the Jenkins Liner, load the brush with Permalba White thinned with Jenkins Happy Medium. The paint should be mixed to a flowing consistency. Place an oval and belly shape in the middle of the circle rose shapes.

Stroke on a small blob of Alizarin Crimson in the center of the orange rose. This will establish the center dark area. Also deepen the bottom belly with Alizarin Crimson.

Using the Jenkins Badger Bright, pick up the Permalba White with no medium and *plunk* a little white at the top of the belly sections. Dry brush the colors around the belly section. Add more white if necessary. We are building up to a strong highlight, it is like building a house, we are currently putting in the foundation, the roof will be last — our final highlight. As you work up to your highlight areas, work with your colors using less Happy Medium in your brush.

1st Stage

2nd Stage

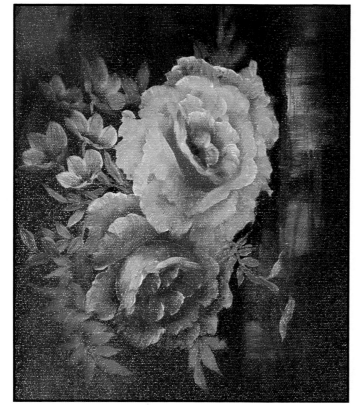

3rd Stage

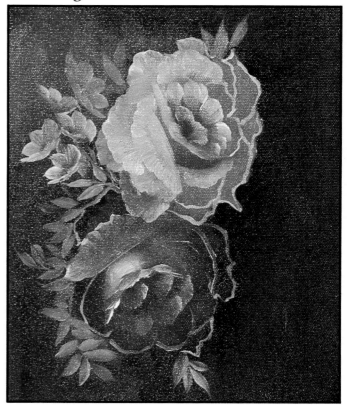

4th Stage

Stage 1
Basic color placement of the roses and leaves are stroked on the canvas.

Stage 2
Color placement of background and leaves are stroked in — line drawing on roses is made.

Stage 3
Rose petals are stroked on following line drawing. Small filler flowers are added to design.

Stage 4
Final highlights and reflections are placed in the painting.

We will stroke on all the rose petals with an overstroke of dry Permalba White (no Jenkins Happy Medium) going right on top of the base color. Starting with the Alizarin Crimson rose, we will stroke in the foreshortened petals (the petals which edges are looking right at us). Work with Permalba White on the dry side (no medium), use the side of the Jenkins Badger Bright and place strokes on the edge of the belly. Following your design, make an outline drawing of the different petals using the Jenkins Liner and Permalba White thinned with Happy Medium. Next, petals are placed inside the rose bowl area. Rose petals are stroked on in a three stroke manner. Stroke straight in the middle and two curved strokes on either side. Continue to build from the center out. Remember to lift up as you stroke towards an existing petal.

To paint a flipped over petal, place one stroke diagonally, then stroke smaller petals toward the center of that stroke.

The orange rose is overstroked in the same manner only using a mixture of Lemon Yellow and Permalba White. Continue to use the Jenkins Badger Bright for the placement of the petals. As you work on the orange rose petals, you may overlap on the Alizarin rose — that is just fine, *get it in there, that's ok!*

Petals are like a fan opening up, with the ridges coming in towards the center — that's how you can show the brush stroke direction. As the outside petals are placed on last, you will pick up some of the dark background around the edge, a translucent effect will occur — that is so beautiful.

Continue to work on the roses, pop out the middle tones with dry Permalba White — gradually work up to the final highlights of pure Permalba White.

Leaves:
Using a mixture of Lemon Yellow and Cadmium Yellow Medium, place a few stems in with the Jenkins Liner brush. Load your Jenkins Badger Bright with the same color mixture and stroke on a few wiggle wiggle style leaves off of these stems.

Using a mixture of Cerulean Blue and Permalba White, apply a few more stems of wiggle wiggle leaves. Place the leaves in a curving direction around the main subject matter — never squared off. An additional grouping of wiggle wiggle leaves are stroked in using a mixture of Phthalo Green and Cerulean Blue. If any of your leaves are too hard, soften by brushing over them lightly with your Jenkins Super Soft Blender.

Small Filler Flowers:
A mixture of Lemon Yellow and Permalba White was used to create the small flowers. Using your Jenkins Badger Filbert, stroke on the individual petals with the push down, pull up stroke. You may wish to add a little Floral Pink to a few of the flowers as an accent color. The centers are dabbed in using Floral Pink and your Jenkins Badger Filbert.

The stems of these filler flowers are painted in a mixture of Phthalo Yellow Green and Permalba White. Thin this mixture with Jenkins Happy Medium to a flowing consistency. Load your Jenkins Liner and begin to stroke on thin stems and some small leaves.

Reflections:
Several colors were used to paint in some reflections below the roses. I used Bright Red, Cadmium Orange, and Cerulean Blue plus White. Load your Jenkins Badger Bright with a single color at a time and stroke on below roses in a downward vertical motion. Using the chisel of the Bright brush, wiggle wiggle through the color in a horizontal direction. This will break up the vertical movement of the stroke. If any hard color edges exist, soften with your Jenkins Super Soft Blender.

Additional leaves may be placed in front of the roses using the wiggle wiggle style leaf. It is nice to overlap the roses with a few leaves.

It is now time to check your painting — are there any areas which are extremely hard edged? If so, softly blend with Jenkins Super Soft Blender.

Finishing:

Sign your name using the Jenkins Liner brush and thinned paint. Let your painting dry thoroughly. Then apply several coats of Jenkins Sta-Brite Spray Varnish to bring out the color intensity.

The following graph has been provided to enable you to enlarge the design. Increase the line graph double or more in size and sketch the design using this drawing as a guide. Do not feel you must copy it exactly—for you are the artist—create your own painting in the process.

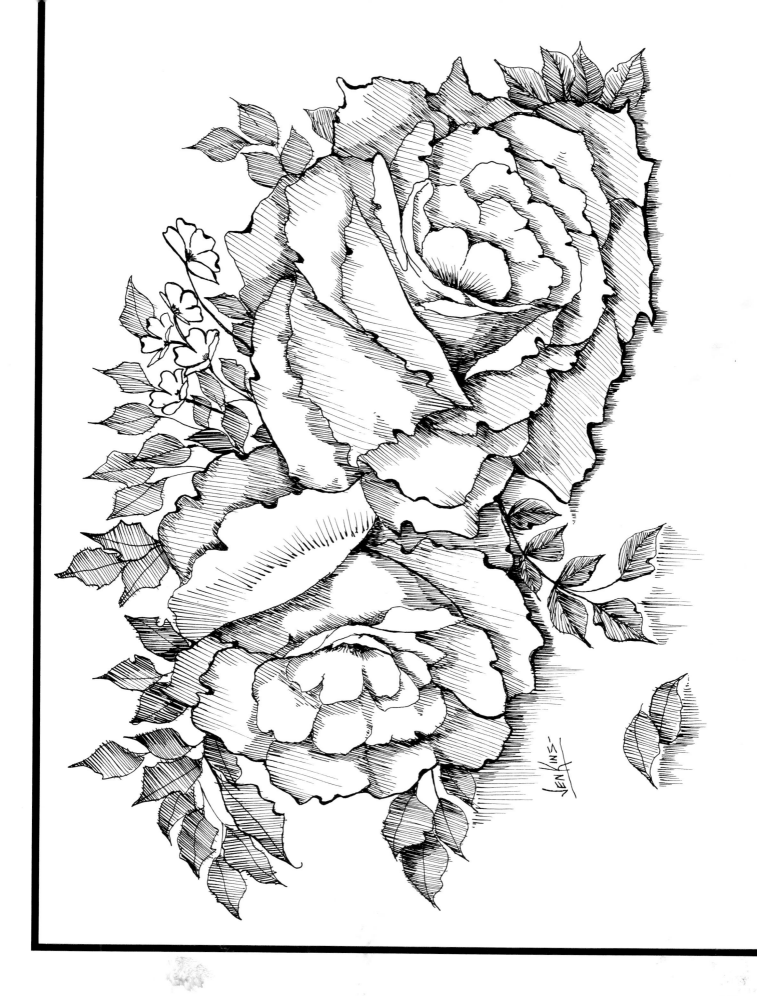

SPRING GERANIUMS

Bright red geraniums are so cheerful. To me, they exemplify springtime to a tee. The warm, rich colors of geraniums are very pleasing to the eye. They are the type of flower which grows in bushy groupings. Geraniums are extremely sturdy and longlasting, they thrive and grow right into summertime.

The thick, velvety leaves of the geranium are most unique. The coloration of the leaves is quite attractive unto itself.

I painted this design with a blended background, ghosting out or throwing part of the background out of focus. I am sure you will enjoy painting this spring-time treat!

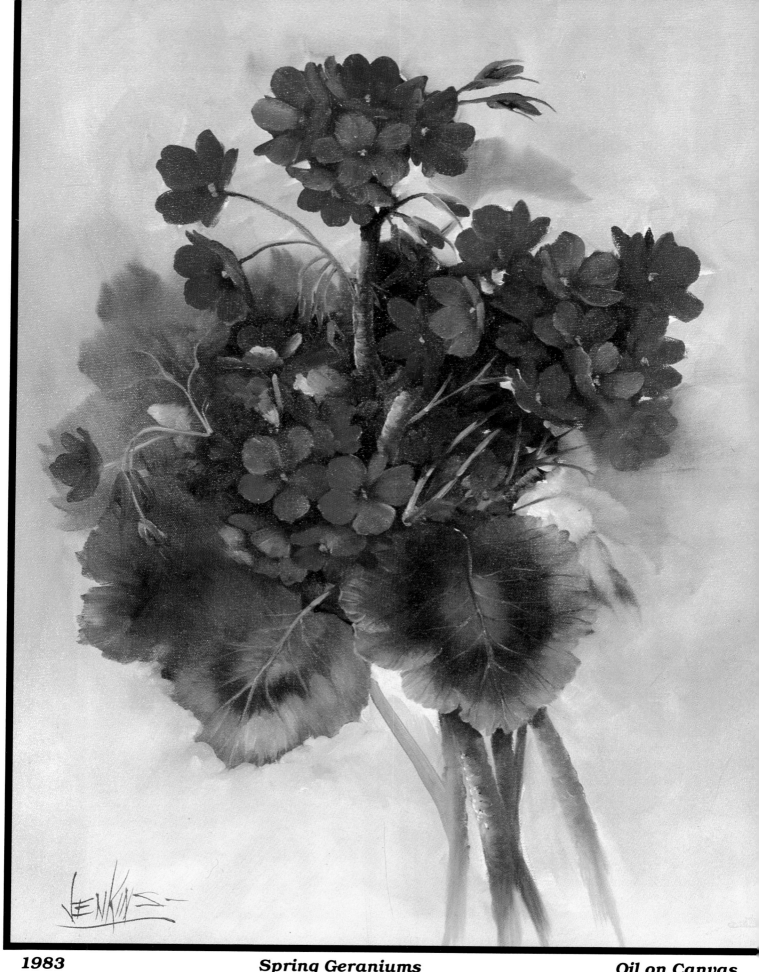

1983 **Spring Geraniums** *Oil on Canvas*

GERANIUMS

Colors

Cadmium Red Light	Sap Green
Alizarin Crimson	Leaf Green
Lemon Yellow	Phthalo Yellow Green
Permalba White	Ivory Black
Yellow Ochre	Cerulean Blue

Brushes

Jenkins Liner
Jenkins Badger Filbert
Jenkins Badger Bright
Jenkins Super Soft Blender

Canvas Preparation: *Basecoat Color*

The geraniums were painted on a blended color background. You may choose to lightly sketch or transfer the design onto the canvas first.

Color Placement: *Leaves*

Block in general leaf color placement with a mixture of Leaf Green and Ivory Black. Use your Jenkins Badger Bright for this color application. Dab the green mix around the flower sections. Be sure to add Jenkins Happy Medium to the oil colors for proper stroking consistency.

Color Placement: *Geraniums*

Block in mass shape sections of the flower groupings with Alizarin Crimson which has been thinned with Jenkins Happy Medium. These color areas may be stroked on with your Jenkins Badger Filbert or Bright.

Color Placement: *Background*

The background was painted in a mixture of Yellow Ochre and Permalba White plus a touch of Alizarin Crimson. This color mix was placed on around the leaves and geraniums color placement with the Jenkins Badger Bright. As you apply the background color, a little of the leaf or flower color may be dragged in to the background — that is ok! The color in the background is stroked on in the criss-cross method. Use some pure Permalba White towards the top of the canvas and around the top grouping of geraniums. All color application on the background is fairly thin, adding Jenkins Happy Medium when needed.

Additional highlights of Floral Pink may be added to the background. Final blending of background should be done with Jenkins Super Soft Blender. This will also remove any paint clumps on the canvas surface.

Color Placement: *Stems*

The stems are blocked in using a mixture of Leaf Green plus Ivory Black with the Jenkins Liner brush. This color mix should be thinned with Jenkins Happy Medium to a flowing consistency.

Leaves:

Fade some of the leaves towards the back of the design by softening them with your Jenkins Super Soft Blender. This will throw them out of focus, creating a very soft look.

The large front leaves are overstroked from the outside edge with the Jenkins Badger Bright and Lemon Yellow. Stroke on a mixture of Cerulean Blue plus Permalba White in the center of main leaf. The dark markings which run around center of the leaf are painted in a mixture of Sap Green and Ivory Black. Highlights go on last, and are placed on dry (no medium). Phthalo Yellow Green is used for the leaf highlights. Veins are put on using your Jenkins Liner brush with very thin flowing consistency Ivory Black. Soften any of the colors on the leaves with the Jenkins Super Soft Blender. Additional highlight work may be placed on the vein with Lemon Yellow.

Accents of Floral Pink, Alizarin Crimson, and Cerulean Blue can be stroked in the leaves.

Flowers:

Individual petals are stroked on using Cadmium Red Light, working on top of the Alizarin Crimson base. When the petals of the flowers are grouped together, you may only see part of a particular flower. Use your Jenkins Badger Filbert to stroke from the tip of the petal to the base. Two to three strokes per petal should be sufficient. Highlights are added to the petals using a mixture of Cadmium Red Light and Permalba White. Only overstroke a few petals here and there with the highlight color. The centers of the geraniums are dots of Lemon Yellow, use the corner of your Jenkins Badger Filbert to dab this color on the flower.

Buds:

The buds are blocked in with Alizarin Crimson using your Jenkins Badger Filbert. The buds of the geranium flower hang over, they are such tired little things. Overstroke the tip of the bud with Cadmium Red Light. Next, we will paint on the calyx of each bud. A mixture of Leaf Green and Lemon Yellow will be stroked on using your Jenkins Liner. This color mix should be thinned with Jenkins Happy Medium to a flowing consistency. Start at the base of each bud and apply pressure to the brush, stroke beyond the tip. You should be forming little strokes which look like leaves.

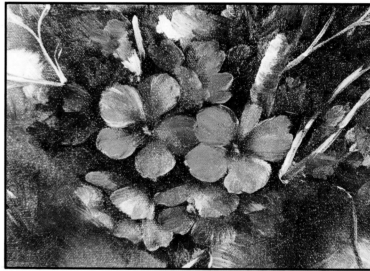

Stems:

Highlight the left side of the stems of the geraniums with Lemon Yellow, Permalba White, and Cerulean Blue. A secondary reflection of Cadmium Red Light is placed on the right side of the stem. You should use your Jenkins Badger Bright to stroke this color on the stems in a horizontal curving motion.

Finishing:

Sign your name using the Jenkins Liner brush and thinned paint. Let your painting dry thoroughly, then apply several coats of Jenkins Sta-Brite Spray Varnish to bring out the color intensity.

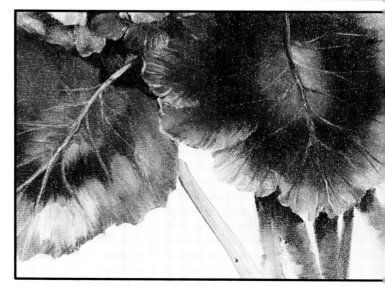

The following graph has been provided to enable you to enlarge the design. Increase the line graph double or more in size and sketch the design using this drawing as a guide. Do not feel you must copy it exactly—for you are the artist—create your own painting in the process.

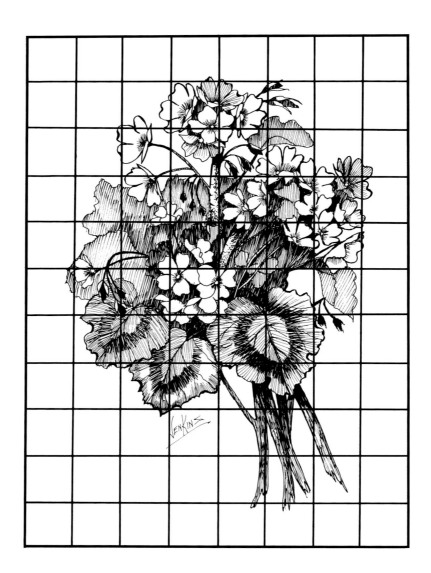

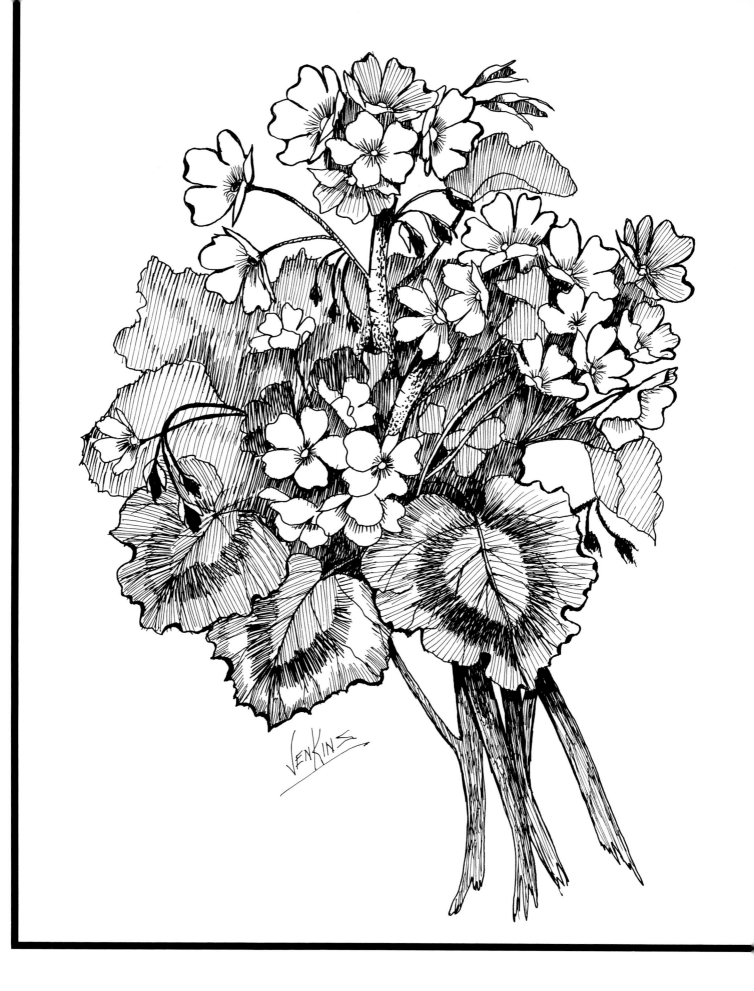

51

BRIGHT SUNFLOWERS

Sunflowers are a joy to paint! They remind me of the country, with big, open, friendly faces. All the individual petals are reaching out to us. The bright, intense yellow hues catch our eye and dazzle us with energy.

In the Midwest, you can have the pleasure of viewing fields of sunflowers. They are truly breathtaking — to see them sway in the wind.

I have painted the sunflowers on a one tone background for a modern graphic look. I feel this painting would go well in a bright sunny kitchen or den. This design will definitely cheer your day up.

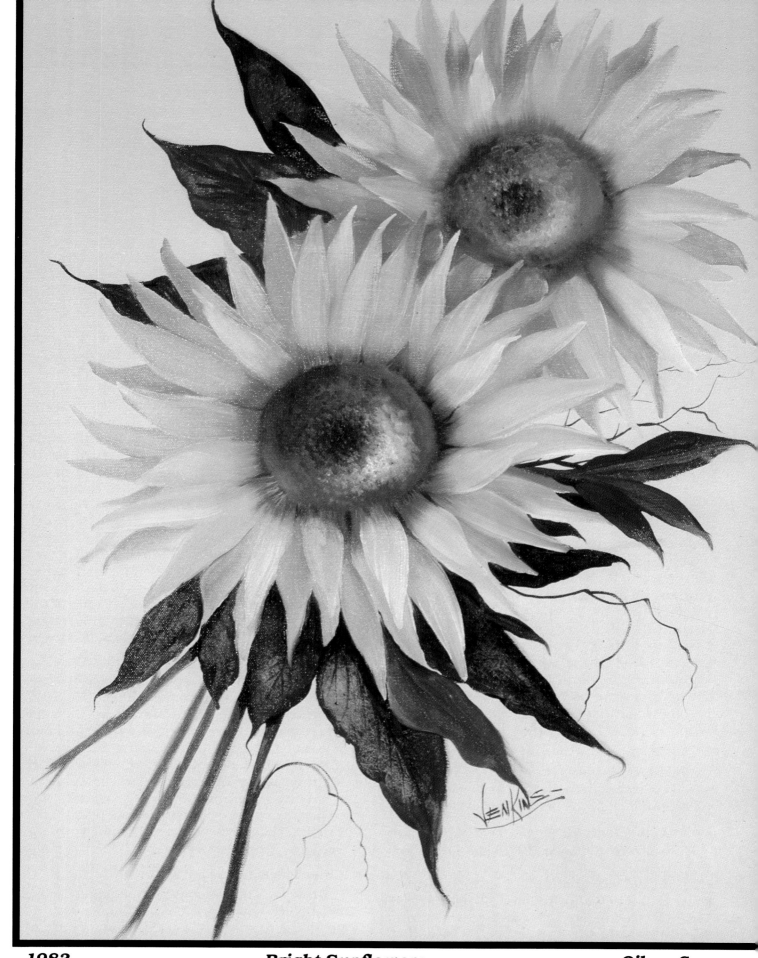

1983 **Bright Sunflowers** **Oil on Canvas**

SUNFLOWERS

Colors

Cadmium Yellow Medium	Ice Blue
Cadmium Orange	Sap Green
Burnt Umber	Leaf Green
Burnt Sienna	Bright Red
Floral Pink	Alizarin Crimson
Lemon Yellow	Permalba White

Brushes

Jenkins Liner
Jenkins Badger Flat
Jenkins Badger Bright
Jenkins Super Soft Blender

Canvas Preparation: *Basecoat Color*

The sunflowers were painted on an off-white acrylic background. Apply a coat of acrylic paint to the canvas using a sponge brush. The paint should be applied evenly and smoothly. We do not want any lumps or bumps on the surface. Two coats should be sufficient. Let it dry thoroughly.

Lightly sketch or transfer the design onto the canvas.

Color Placement: *Sunflower Centers*

Starting with your Jenkins Badger Filbert, dab on Burnt Umber in the dark center area. Be sure to add a little Happy Medium to your oil colors — for proper painting consistency. Around this dark center area, dab on Burnt Umber and Burnt Sienna towards the top and bottom areas of the sunflower center. Place Cadmium Orange and Permalba White around the bottom sections. Gradually work up to the highlight area using dry (no medium) Permalba White.

A small area of reflective light in Ice Blue was dabbed on the lower sunflower center. This should be placed from the nine o'clock to the five o'clock area.

Color Placement: *Sunflower Petals*

Place Alizarin Crimson, Bright Red, and Floral Pink around the sunflower's center. Bring this ring of color out about one-half inch. Stroke these colors on using Jenkins Badger Bright. Base the rest of the petal area in Cadmium Orange.

Now that the sunflowers have the base color placement applied, we will start to stroke in the individual petals. To paint the petals, load your Jenkins Badger Bright with a mixture of Permalba White and Lemon Yellow, and place the brush at the tip of each petal and stroke towards the center. Touch the brush to the surface, apply pressure, drag, and lift up as you come towards the center. You will naturally pick up some of the red tones towards the center — this is ok. It is not necessary to clean the brush each time, just load the brush with more Permalba White and Lemon Yellow and place a row of petals all around the flower. Now begin to pick up more Permalba White which is dry (no medium) and begin to highlight some of the petals — not all petals. Shorter petals of straight Permalba White can be randomly added to the flower.

The next step is to pick up your Jenkins Super Soft Blender and pull out the red tones around the center area. Start from the edge where the petals are attached to the center and pull the color out onto the petals with the brush. This area may need to be deepened with the addition of Burnt Umber. Dark accents will strengthen the area around the center. This color can be stroked on with your Jenkins Liner brush. Blend and soften this area with the Jenkins Super Soft Blender.

Color Placement: *Leaves*

Brush mix Sap Green and Burnt Sienna to a deep green with your Jenkins Badger Flat. We are going to sneak this color around our sun-

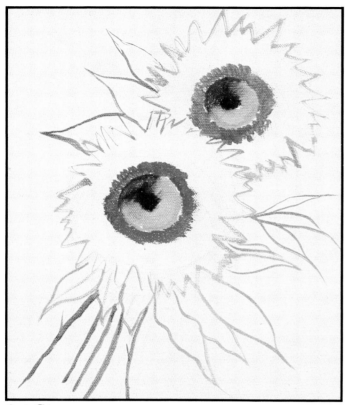

1st Stage

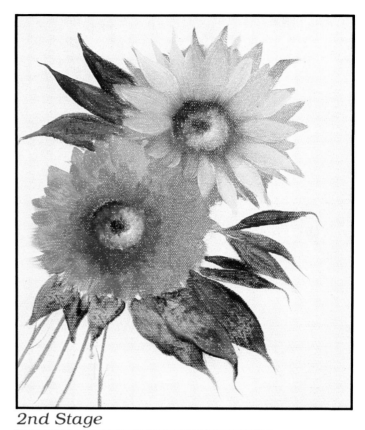

2nd Stage

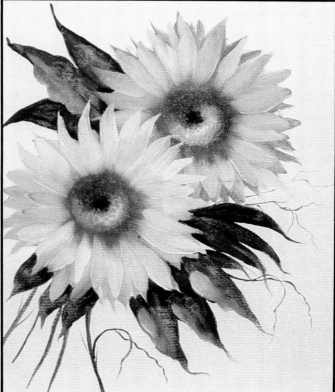

3rd Stage

4th Stage

Stage 1
Basic color placement of the sun-
flower's center is dabbed on the
canvas. Along with initial color
set-up on the petals.

Stage 2
Further color placement of petals
is made along with leaf color place-
ment. Initial petals are stroked on.

Stage 3
Midtone petals have been stroked
on the sunflower. Texture is applied
to the sunflower's leaves.

Stage 4
Final highlights, accents, and
blending occurs to the sunflowers
and leaves.

flower petals where the leaves tuck under the flowers. We are painting the leaves last, so we do not pick up the dark green into the flower petals.

Coat the remaining leaf shape with Sap Green and Leaf Green. The leaves are highlighted by picking up an absorbent paper towel and hitting the surface to remove the paint. This will leave the white canvas showing through as our highlight.

Stems:

The stems are painted in the dark green mixture which was thinned with Jenkins Happy Medium to a flowing consistency. Small vines may be added here and there to give more interest and break up the composition. The stems and vines are painted using your Jenkins Liner.

Finishing:

Sign your name using the Jenkins Liner brush and thinned paint. Let your painting dry thoroughly, then apply several coats of Jenkins Sta-Brite Spray Varnish to bring out the color intensity.

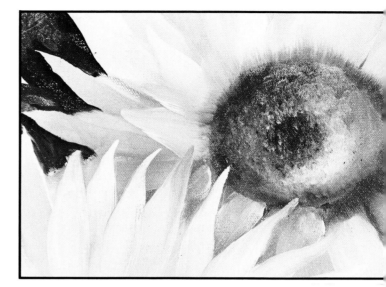

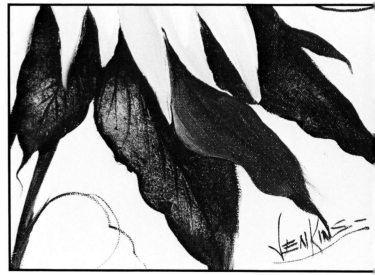

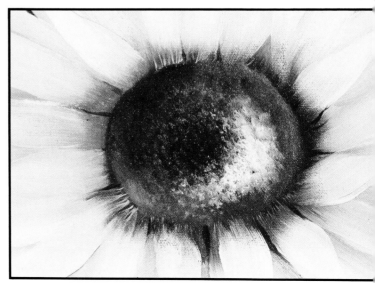

The following graph has been provided to enable you to enlarge the design. Increase the line graph double or more in size and sketch the design using this drawing as a guide. Do not feel you must copy it exactly—for you are the artist—create your own painting in the process.

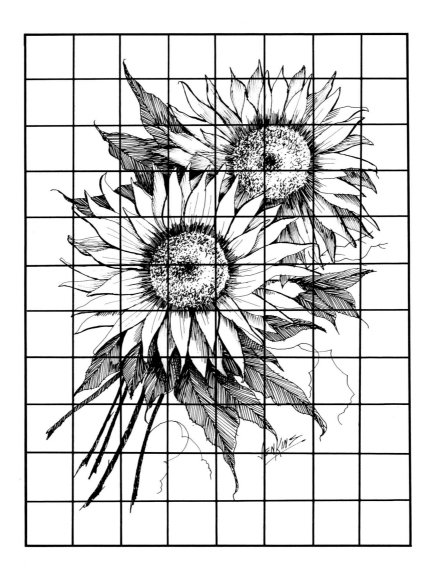

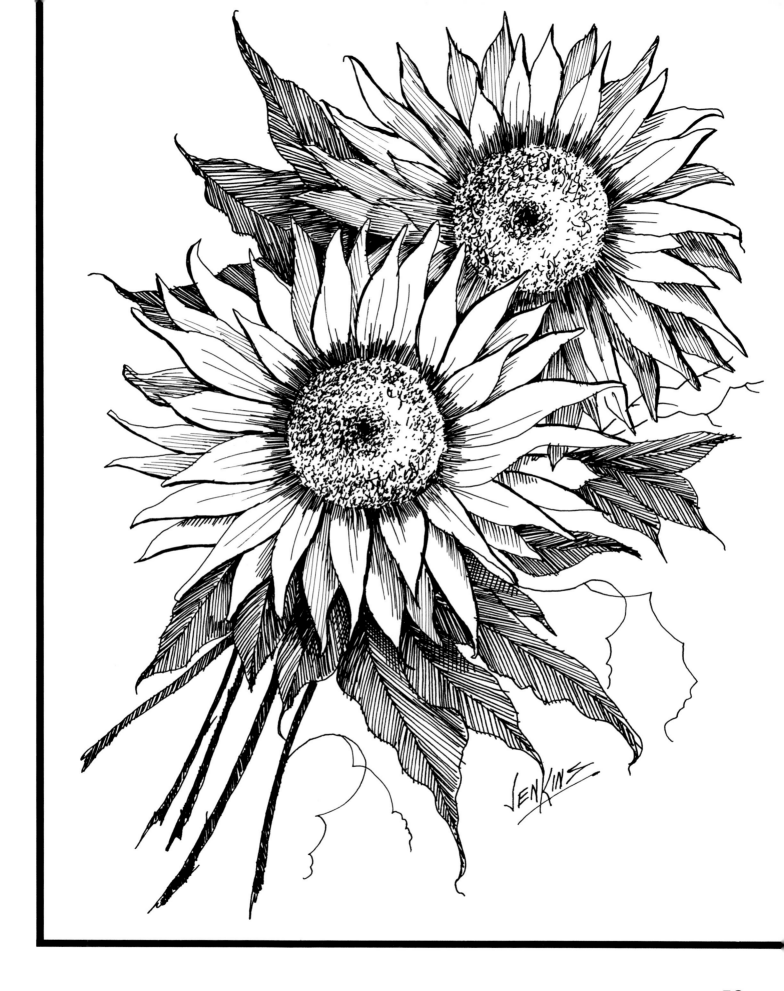

PRECIOUS POPPIES

Big, bold, golden poppies in a copper pot — what an elegant addition to any room. The flowing and fanning petals of the poppy painted on canvas will grace anyones wall grouping.

My poppies have become one of my trademarks. They have been tremendously popular over the years. I have mentally crossbred a California poppy, an Icelandic poppy, and an Oriental poppy until I got the flower I desired.

The soft, delicate transparency of my poppy petal is one of the key reasons that make them stand out. They easily call for your attention. I know you will really enjoy painting this subject matter.

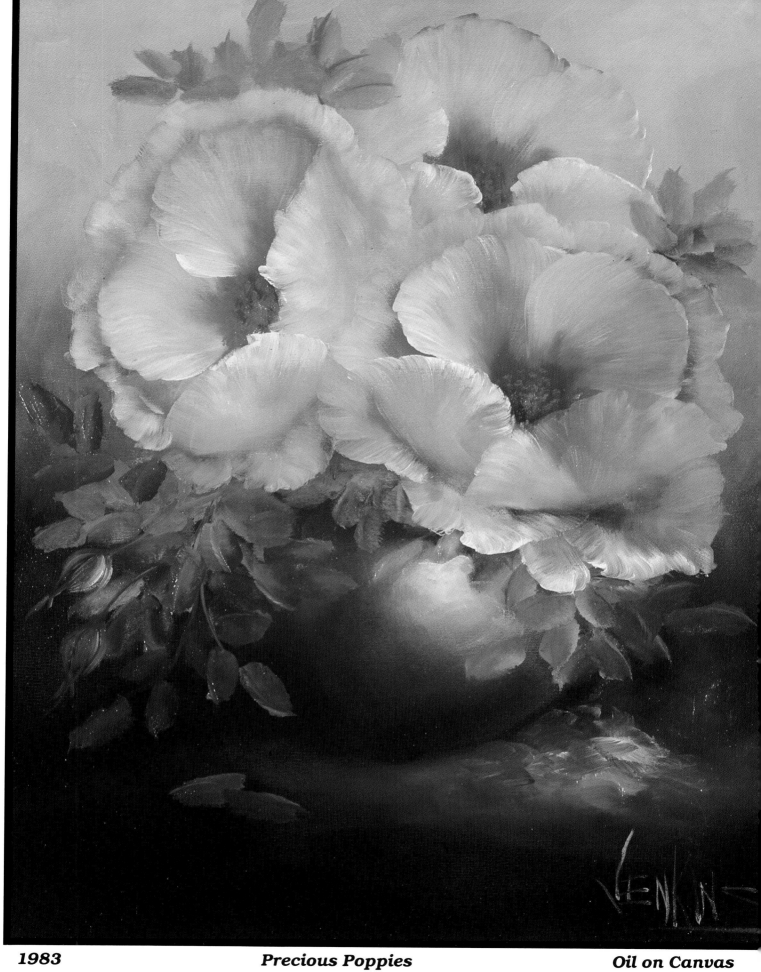

1983 *Precious Poppies* *Oil on Canvas*

POPPIES

Colors

Burnt Umber	Cadmium Yellow Medium
Burnt Sienna	Permalba White
Yellow Ochre	Sap Green
Alizarin Crimson	Leaf Green
Floral Pink	Cerulean Blue
Cadmium Orange	Lemon Yellow
	Phthalo Yellow Green

Brushes
Jenkins Liner
Jenkins Badger Filbert
Jenkins Badger Bright
Jenkins Super Soft Blender

Canvas Preparation: *Transfer Design*

We will begin by lightly sketching or transferring the design to the canvas. Be careful not to bear a lot of pressure when transferring design, or you can make an indentation into the canvas.

Color Placement: *Background*

Using the Jenkins Badger Bright, apply a mixture of Burnt Umber and Burnt Sienna to the lower one-third of the canvas. Apply the paint to the surface in the criss-cross stroke method. In the middle one-third of the background apply Phthalo Yellow Green and on the top one-third apply Permalba White plus Ice Blue.

Break up the color division by softly blending with your Jenkins Super Soft Blender. I have purposely left the background a little brush strokey. It will give the painting more interest. You should never blend so much that a one tone background is achieved.

Color Placement: *Poppies*

Before you begin to paint the poppies, refer to the finished painting and notice the stroke direction of the petals. They begin at the edge and flow to the center.

Using your Jenkins Badger Bright, brush mix Cadmium Orange and Burnt Sienna and base the three poppies in this coloration. Apply color following the natural shape of the flower petals.

After this is completed, thin Permalba White to a flowing consistency with Jenkins Happy Medium. Lightly sketch in a basic line drawing of the individual petals.

Using your Jenkins Badger Bright, apply Alizarin Crimson to the center area of each poppy — blend outward.

Color Placement: *Copper Pot*

A mixture of Burnt Umber and Burnt Sienna are stroked on the left side curving down to the bottom of the pot with your Jenkins Badger Bright. Apply the paint in the criss-cross method. Place Yellow Ochre on the right side of the pot. Blend the area where these colors meet with your Jenkins Super Soft Blender.

Color Placement: *Leaves*

The leaves are painted in the wiggle wiggle style using a mixture of Sap Green plus Burnt Sienna.

Poppies:

We will now begin to stroke on the individual petals of the poppy. A mixture of Lemon Yellow and Permalba White is stroked on using your Jenkins Badger Bright. To start, place the chisel edge of the brush at the tip of the petal. Touch the brush to the surface, apply pressure, pull, drag, and lift up as you come in towards the center.

Think of a fan when shaping this petal and follow the line drawing that you have previously established. You will pick up the base tone color and other surrounding colors into the flower —

this is ok! In fact, it will add to the transparency effect. Stroke on the back petals first and work up to the petals in the front.

Using your Jenkins Badger Filbert, dab on Cadmium Orange in the center pollen area of each poppy.

Leaves:

Additional leaves coming over the poppies may be added to break up any compositional problems. The leaves are accented with Leaf Green and stems are stroked in with your Jenkins Liner.

Copper Pot:

The copper pot is highlighted with Permalba White. To accomplish this highlight area, mix Yellow Ochre and Permalba White together and stroke on with your Jenkins Badger Bright. Next, stroke on some more Permalba White on this area. Lastly, stroke on final highlight of pure, dry (no medium) Permalba White.

Reflections:

Several colors were used to paint in some reflections below the poppies and copper pot. I used Yellow Ochre, Floral Pink, Cadmium Orange, and Cerulean Blue plus White. Load your Jenkins Badger Bright with a single color at a time and stroke on below the copper pot. I applied this reflection slightly different than any of the others in this book. The reflections were stroked on in the criss-cross method. Lightly blend reflections with your Jenkins Super Soft Blender.

Additional leaves may be placed in front of the design on the ground. This will give a flowing feel to the composition.

It is now time to check your painting — are there any areas which have extremely hard edges? If so, softly blend with your Jenkins Super Soft Blender.

Finishing:

Sign your name using the Jenkins Liner brush and thinned paint. Let your painting dry thoroughly. Then apply several coats of Jenkins Sta-Brite Spray Varnish to bring out the color intensity.

The following graph has been provided to enable you to enlarge the design. Increase the line graph double or more in size and sketch the design using this drawing as a guide. Do not feel you must copy it exactly—for you are the artist—create your own painting in the process.

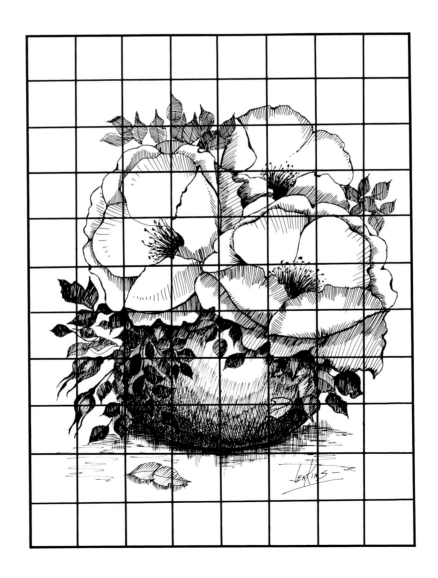

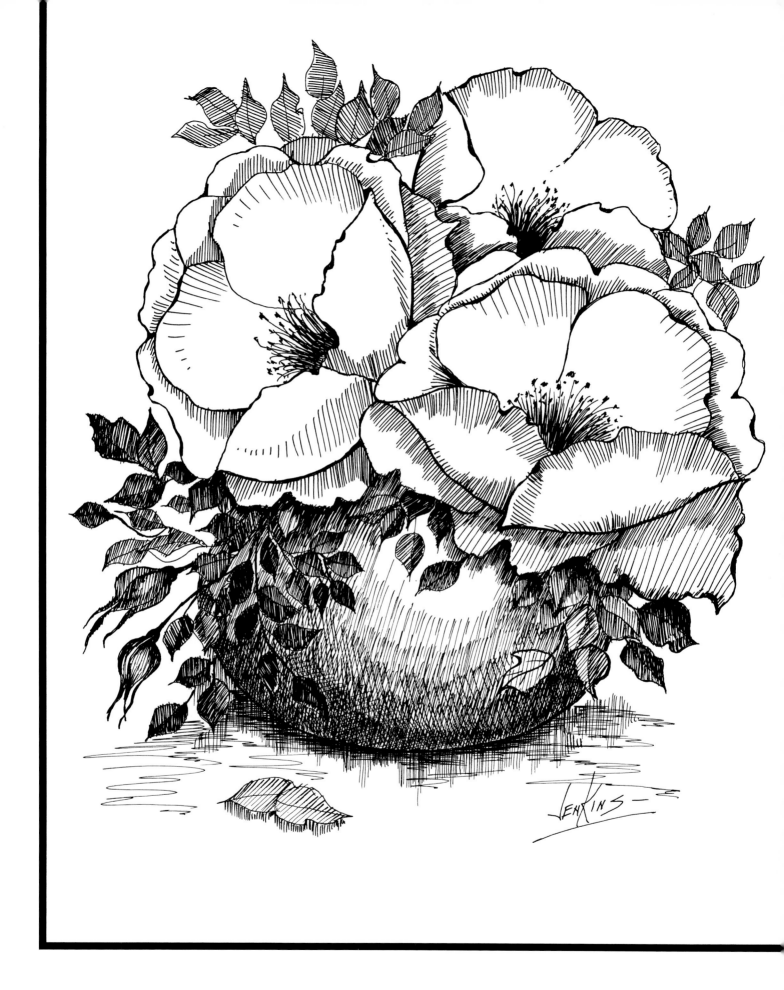

A HAPPY PANSY

The smiling face of a happy pansy is such a pleasure to behold. They are a bold but delicate flowers. The petals seem to gracefully ripple with splendid movement. The markings of the pansy are quite unique — creating a burst of color and energy from the center.

I choose to paint this happy red pansy on an off-white background for the graphic modern look. If you plan to paint a grouping of pansies, be sure and vary the coloration of them. Pansies come in so many variations, it would be very boring to paint them all alike!

HOWARD BEHRENS

Size 38" x 42" "Portofino Gardens" Original Oil

Phantom Chase

"The scope of the project significantly expanded," Sterling said. It changed to a 2,700-seat theater, a 595-seat theater and a community room for dinner theater and parties.

All of a sudden, more money than anyone had imagined was needed. The budget grew to $38 million and the mix of funding sources was shaken up. The board killed the idea of bank bonds and asked for more private donations—from $3 million to $10 million.

At the same time, the money raisers got a big break—developer August Urbanek's Au-Rene Foundation pledged $3.5 million. (The donation got the Foundation's name on the big theater.)

Donors aside, this newly broadened project needed other infusions, and that meant public funds. The savior, this time, came in the form of a $7.75-million state's public education capital outlay grant.

Behind the scenes, the center's executive director Sid McQueen and the board were at odds. "There were lots of egos involved," said McQueen. He resigned in 1987. A. Hugh Adams, the former president of Broward Community College, agreed to take over temporarily, with the mission to get things moving again.

"All we had out there was a pile of dirt and a gold brochure," he said. "We had to sell it. This time, the time was right."

Using the grit he learned on a college football field and in the Navy, Adams pushed ahead until the architects—Benjamin Thompson & Associates—told h[...] in mid-1988 that the project would cos[...] million more. "It was another dif[...] crisis," he said. "We had to gird ou[...] and move on."

And they did. Ground was broke[...] as the structure began to take form[...] array of problems piled up. Des[...] changes. Flooded orchestra pits. So[...] land. A stage with no trap door[...] "Phantom." Solvable obstacles, but co[...]

"I sat in my office more than once try[...] to piece things together, and I'd laug[...] Adams said. "I'd say to myself, 'What a[...] I doing here? I don't want a second career[...] But, he added, "The real issue is not[...] there are problems, but do the benefi[...] outweigh the problems in the end? An[...] the answer is yes."

With the building under way, Willia[...] Farkas, former director of the Downtow[...] Development Authority, stepped in a[...] director. During his tenure, he has seen a[...] tremendous amount of money raised, but[...] the effort slowed to a trickle this summer.[...] Adams was asked to come to the rescu[...] again. The campaign for private dollar[...]

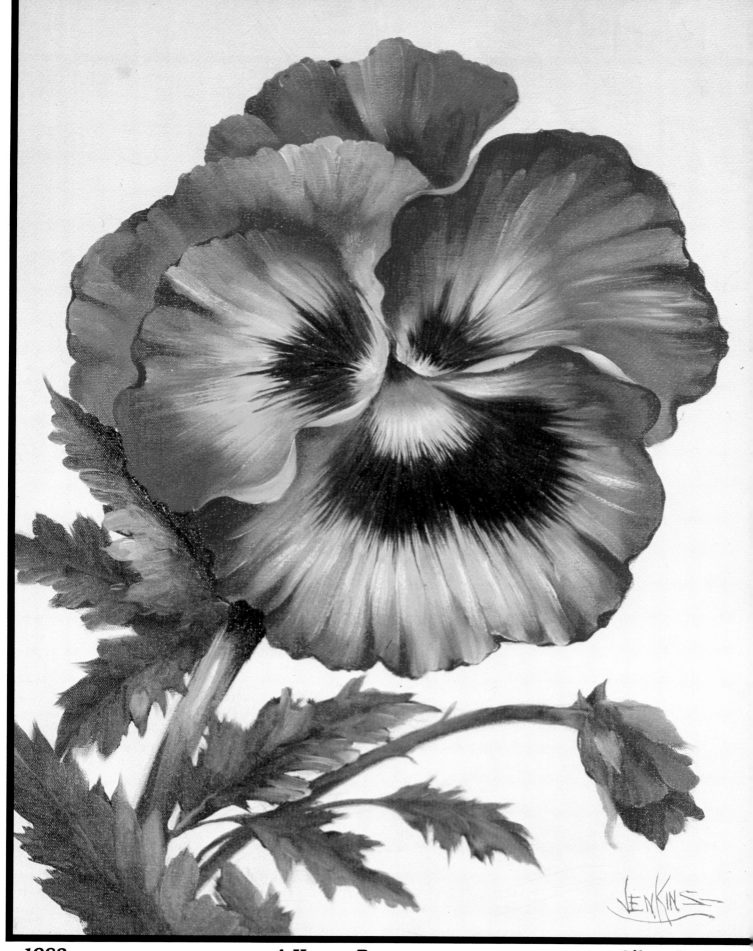

1983 **A Happy Pansy** **Oil on Canvas**

PANSY

Colors
Cadmium Orange
Bright Red
Alizarin Crimson
Floral Pink
Sap Green
Phthalo Yellow Green
Cadmium Yellow Medium
Lemon Yellow
Ivory Black
Permalba White

Brushes
Jenkins Liner
Jenkins Badger Filbert
Jenkins Badger Bright

Canvas Preparation:

The pansy was painted on an off-white acrylic background. Apply a coat of acrylic paint to the canvas using a sponge brush. The paint should be applied evenly and smoothly. We do not want any lumps or bumps on the surface. Two coats should be sufficient. Let dry thoroughly.

Lightly sketch or transfer the design onto the canvas.

Color Placement: *Petals*

To start, apply a mixture of Cadmium Orange and Bright Red to the outer edge of the front three petals. Place Cadmium Orange plus Cadmium Yellow medium to the outer edge of the two back petals. Using your Jenkins Badger Bright, apply Lemon Yellow thinned with Jenkins Happy Medium next to the last row of color about two inches toward the center area. Also place Alizarin Crimson in the shadow areas. Blend all these areas where they meet with the Jenkins Badger Bright.

Using Bright Red plus Ivory Black, begin to stroke color on in the stripped mid-section with the chisel edge of your Jenkins Badger Bright. Stroke over this area with the Jenkins Liner, pulling this dark color out towards the petal's edge and in towards the center. The paint must be thinned with Jenkins Happy Medium in order for the linework to flow properly.

Next, place Phthalo Yellow Green in the very center of the pansy using your Jenkins Badger Filbert. Deepen this inner area with a touch of Ivory Black.

Highlight the center areas of the three main front petals with Permalba White. Also place Permalba White on the turned ruffled areas, additional contrast can be added to the turned edge by placing Alizarin Crimson next to it.

To give the feel of ripples in the petals, stroke on streaks of Alizarin Crimson from the petal's edges. Add in final wrinkles on the petals in Alizarin Crimson using your Jenkins Liner.

Stem:

The stem is painted in Phthalo Yellow Green plus Cadmium Orange (this will soften the green). Using your Jenkins Badger Filbert, stroke on Ivory Black where the stem goes underneath the pansy. This will create a shadow area. Lemon Yellow is stroked on in the middle of the stem with a shot of Permalba White for a nice shiney highlight.

Color Placement: *Leaves*

Place a mixture of Sap Green and Ivory Black thinned with Jenkins Happy Medium on the pansy leaves. Using your Jenkins Badger Filbert, stroke from the tip of the ragged edges in towards the center vein area. Highlight the leaves with Phthalo Yellow Green and Lemon Yellow. Tip the leaves in a few areas with Floral Pink. Be sure to keep these leaves very ragged.

Bud:

Undercoat the bud shape with a coat of Alizarin Crimson which has been thinned with Jenkins Happy Medium. Overstroke the very edge of the bud with Bright Red using your Jenkins Badger Filbert. Start at the tip and stroke in.

1st Stage

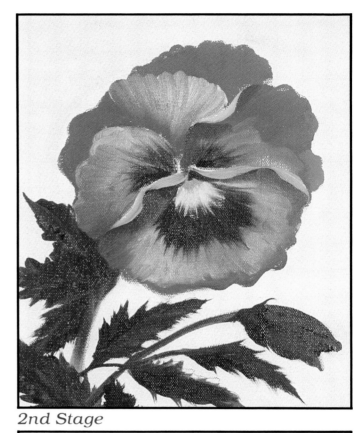

2nd Stage

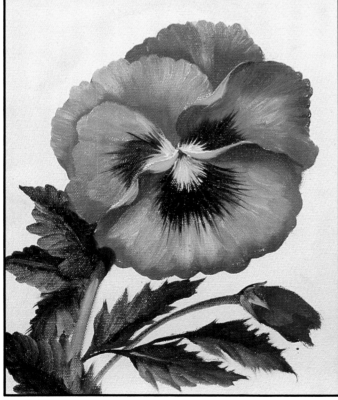

3rd Stage

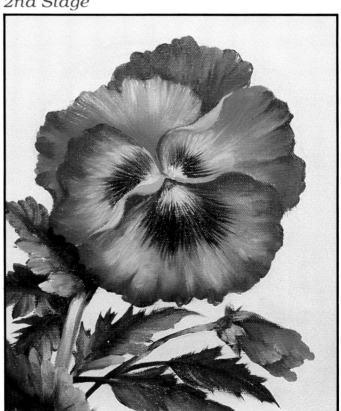

4th Stage

69

Stage 1
Basic color placement of petals is stroked on the pansy.

Stage 2
Additional color placement is made on the petals of the pansy. The pansy leaves and bud are stroked on the canvas.

Stage 3
Highlights and accents are stroked on the flower, leaves, and bud.

Stage 4
Final blending and streaking of color is made on the flower and leaves.

The bud calyx is stroked over the bud with Phthalo Yellow Green and Sap Green.

Finishing:

Sign your name using the Jenkins Liner brush and thinned paint. Let your paint dry thoroughly, then apply several coats of Jenkins Sta-Brite Spray Varnish to bring out the color intensity.

The following graph has been provided to enable you to enlarge the design. Increase the line graph double or more in size and sketch the design using this drawing as a guide. Do not feel you must copy it exactly—for you are the artist—create your own painting in the process.

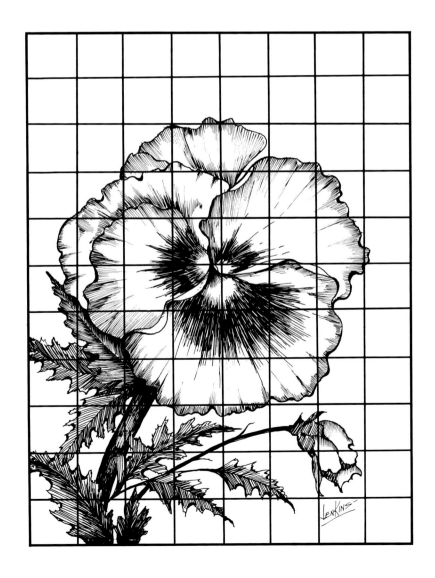

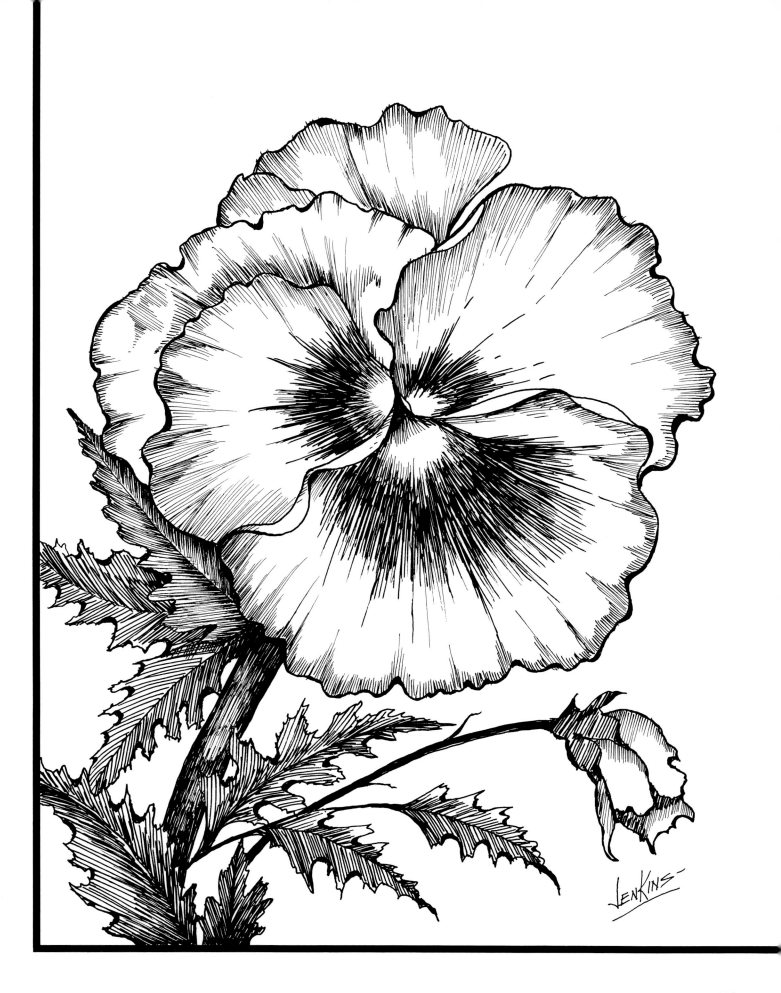

WILD FLOWERS

Rustic simple wild flowers have been joined with field leaves, branches, and a butterfly. An unusual textured background treatment was applied around the oval for a further natural effect.

I feel pairing up strong natural earth tones with soft pastel hues creates an interesting contrast. The light pink, yellow, and white flowers really talk to us. Those flowers stand up and call attention to themselves. Their gracefulness is exemplified in this rustic field setting.

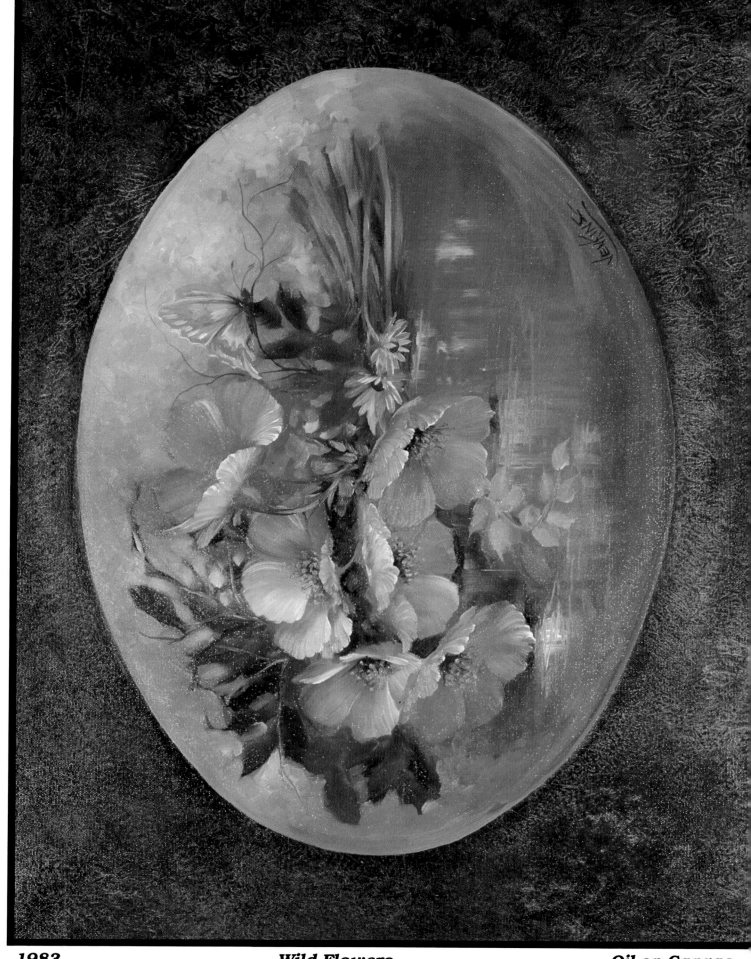

1983 *Wild Flowers* *Oil on Canvas*

WILD FLOWERS

Colors

Burnt Umber

Lemon Yellow

Sap Green

Burnt Sienna

Floral Pink

Cadmium Orange

Permalba White

Cerulean Blue

Mauve

Yellow Ochre

Brushes

Jenkins Liner

Jenkins Badger Flat

Jenkins Badger Filbert

Jenkins Badger Bright

Jenkins Super Soft Blender

Canvas Preparation: *Background*

Lightly sketch or transfer the oval shape and flower design onto the canvas. Now, place Burnt Umber which has been thinned with Jenkins Happy Medium all around the outside area of the oval shape. Next, wad up textured paper toweling and begin to pat, pat, and pat on the canvas surface, this will create a marked, irregular pattern in the Burnt Umber area. This can be brushed out if it does not work the first time. It will look better if it is not uniform.

Color Placement: *Wild Flowers*

Block in the large wild flowers in the following colors: White flowers in a mixture of Permalba White plus Burnt Umber plus Mauve; Pink flowers in Floral Pink; and the Yellow flowers in a mixture of Yellow Ochre and Burnt Sienna.

Color Placement: *Background*

The background in this painting is a modeled one in which colors are shaped and stroked to create a texture and dimension. The top section of the canvas background has quite a few colors in it with the bottom section painted simpler. The quiet bottom area will balance out the top busy area.

Permalba White, Lemon Yellow, Cerulean Blue, and Floral Pink were placed on the top section in the criss cross method. Do not over blend, you want to achieve hints of many colors in the background. The following colors were then stroked on the bottom section: Burnt Sienna, Yellow Ochre, Permalba White, and Burnt Umber. Brush these colors on slowly tieing into the colorful top section. Your background coloration may not be *exactly like mine — that's ok!* It is hard to reproduce the same background twice with this method.

Color Placement: *Leaves*

The leaves in this design are painted an earth tone green. Mix Burnt Umber and Leaf Green to create this subtle background green. Stroke this color on using your Jenkins Badger Filbert.

Wild Flowers:

The wild flowers are overstroked in the same technique regardless of their color. Pick up some of the respective base color that you used before and add more Permalba White to it. Use this to overstroke the individual petals of the wild flowers. Start at the edge of the petal and stroke in towards the flower's center. You should lift up the brush before reaching the center. The flower petals should flow and ripple — do not paint them straight and stiff.

Using your Jenkins Liner and Burnt Sienna which has been thinned with Jenkins Happy Medium stroke on thin stamen lines coming from each flower's center. These lines should flow off the brush's point, curving with much movement. At the end of each stem, a dab of Cadmium Yellow Medium is placed on for the pollen section. Use your Jenkins Liner and thick paint for this pollen section.

Leaves:

The leaves are highlighted in only a few places with a mixture of Leaf Green and Lemon Yellow. There are no highlights placed on the left hand back leaves.

Butterfly:

The wings of the butterfly are based in Yellow Ochre and the body is based in Burnt Umber using your Jenkins Badger Filbert.

The markings of the wings are painted with Permalba White stroked on with your Jenkins Badger Flat. The bright spot on the front wing is painted in a mixture of Floral Pink and Cadmium Orange.

Stems and Twigs:

Stems of Leaf Green are stroked on with the chisel edge of your Jenkins Badger Bright. Highlight the stems with Lemon Yellow.

Twigs of Burnt Umber are stroked on using your Jenkins Liner and paint which has been thinned to ink consistency. Highlight the twigs with Cadmium Orange.

Reflections:

Several colors were used to paint in some reflections below the wild flowers. I used Cadmium Yellow Medium, Floral Pink, Cadmium Orange, and Cerulean Blue plus White. Load your Jenkins Badger Bright with a single color at a time and stroke on below the flowers in a downward vertical motion. Using the chisel of the Bright brush, wiggle wiggle through the color in a horizontal direction. This will break up the vertical movement of the stroke. If any hard color edges exist, soften with your Jenkins Super Soft Blender.

Additional leaves may be placed in front of the design using the wiggle wiggle style leaf. It is nice to overlap the flowers with a few leaves.

It is now time to check your painting — are there any areas which have extremely hard edges? If so, softly blend with your Jenkins Super Soft Blender.

Finishing:

Sign your name using the Jenkins Liner brush and thinned paint. Let your painting dry thoroughly. Then apply several coats of Jenkins Sta-Brite Spray Varnish to bring out the color intensity.

The following graph has been provided to enable you to enlarge the design. Increase the line graph double or more in size and sketch the design using this drawing as a guide. Do not feel you must copy it exactly—for you are the artist—create your own painting in the process.

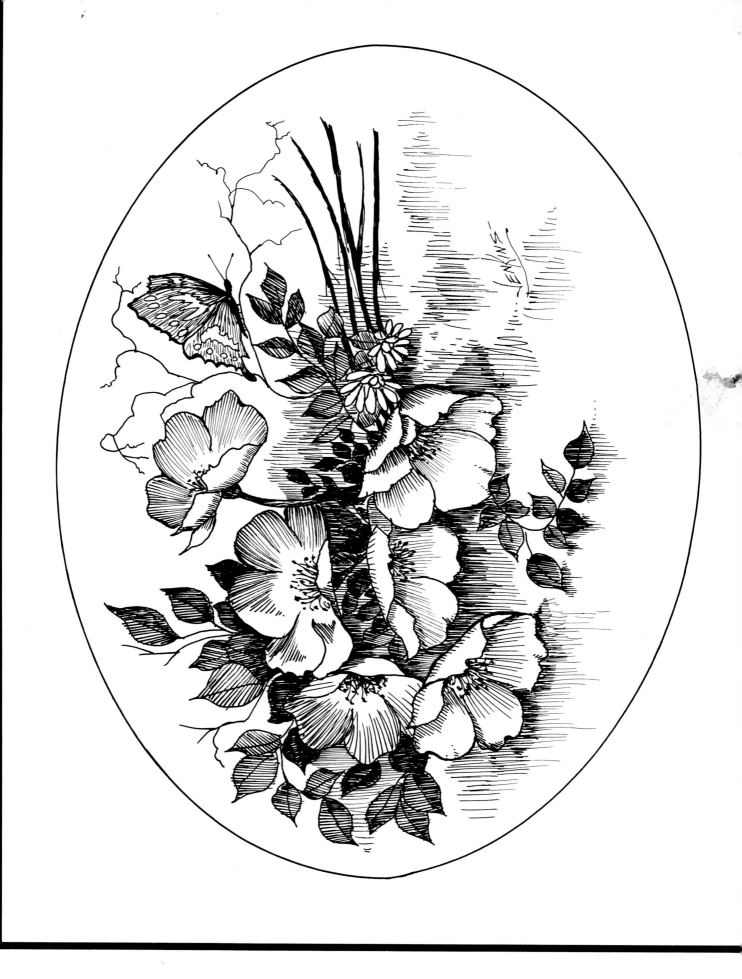

Additional Artwork
We thought you would enjoy viewing some paintings by Gary, depicting his versatile talent of truly any subject matter. Look for other publications featuring his unique style in the future.